JOHNNY CASH

PHOTOGRAPHS BY LEIGH WIENER

JOHNNY CASH

PHOTOGRAPHS BY LEIGH WIENER

PREFACE BY GRAHAM NASH

fiveTIES

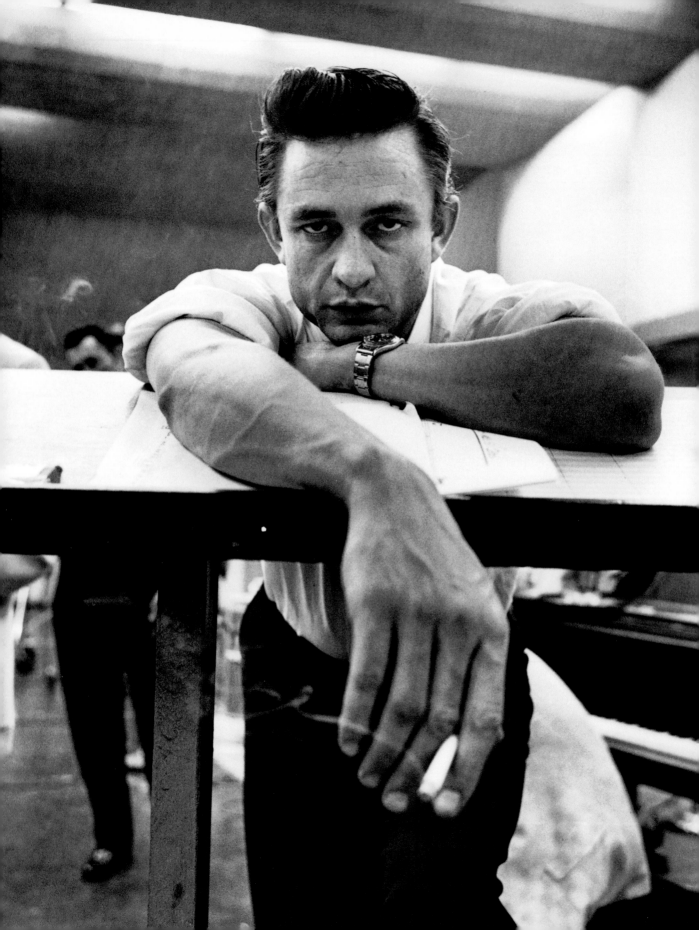

PREFACE

The man was real. The man was intense and utterly committed…to his family, his music, and the plight of the underprivileged men and women that he related to so well.

I first met Johnny in 1969. My girlfriend, Joni Mitchell, was performing on his television show in Nashville, Tennessee, at the Ryman Auditorium, home of the Grand Ole Opry… along with Bob Dylan, Ed Ames, and…The Monkees. He was polite and friendly to everyone around. Now I'm sure that wasn't always the case. After all, he was a saint and a sinner…to the max…but when he invited us to dinner at his home, you knew he meant it.

At the end of the meal Johnny got up and tapped a wineglass with a golden fork. "Here at the Cash household we have a tradition. We provide the food, and you sing for your supper," he said in that great voice of his. "So who's gonna start?" Nobody moved a muscle…after all, Bob was there sitting on the stairs with his wife, Sara, in public again after his motorcycle accident a few years earlier. He was in town recording the album that would become *Nashville Skyline*. Finally I couldn't stand the tension anymore, and I got up to sing a new song, "Marrakesh Express"… I was doing pretty well until the final chord of my song…with a flourish I stood up and walked into a floor lamp. Everyone laughed nervously, breaking the tension in the room. The evening ended up with Dylan singing two or three songs from the album…a truly memorable night, one in which I gained a great respect for the Man in Black.

He wore black for the downtrodden, the forgotten, and the imprisoned…He decided that he wouldn't wear colors until all people were free and were treated with the respect they deserve. When you finish looking at the photographs in this book, you'll realize that it's hard to forget a man like Johnny Cash. My friend Leigh Wiener took these shots between April of `60 and April `62. They are about as honest as the day is long…just like Johnny Cash…Enjoy.

GRAHAM NASH, 2006

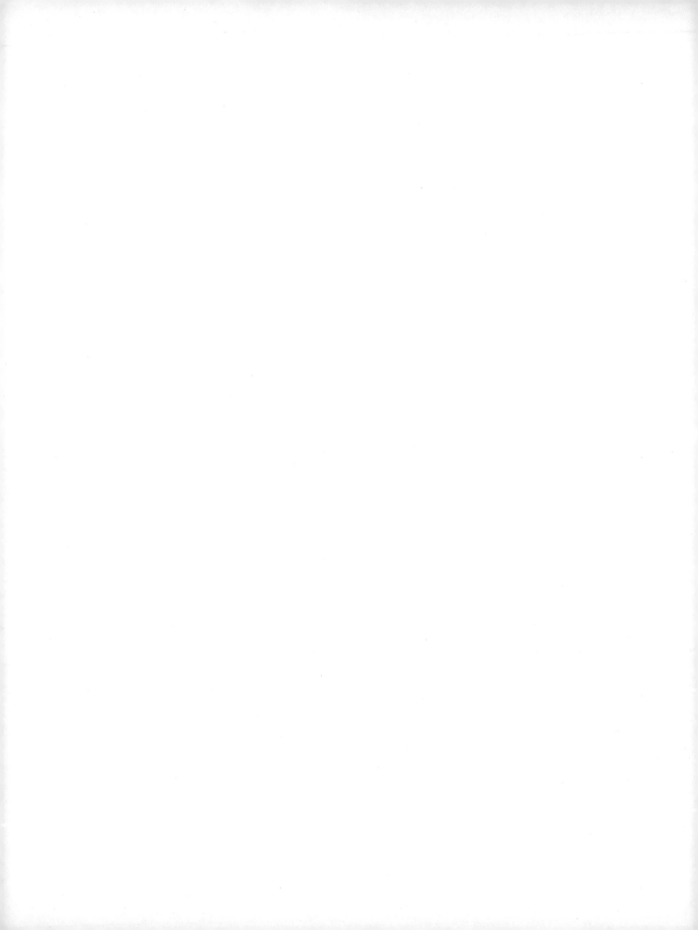

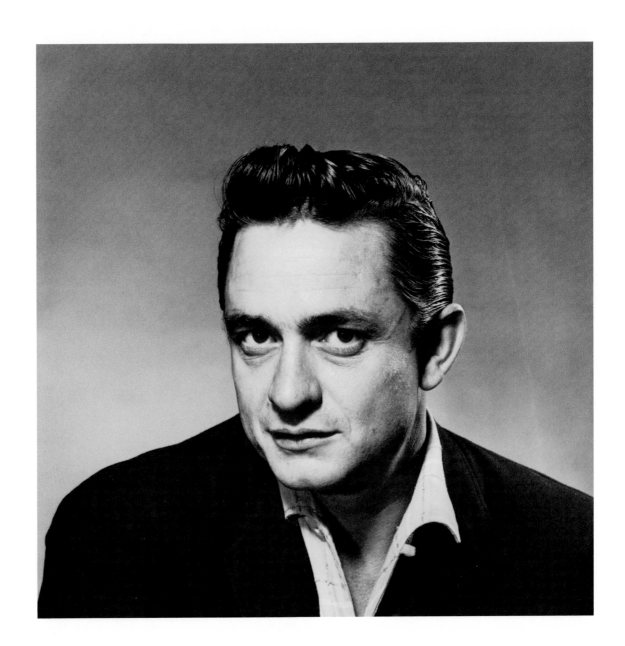

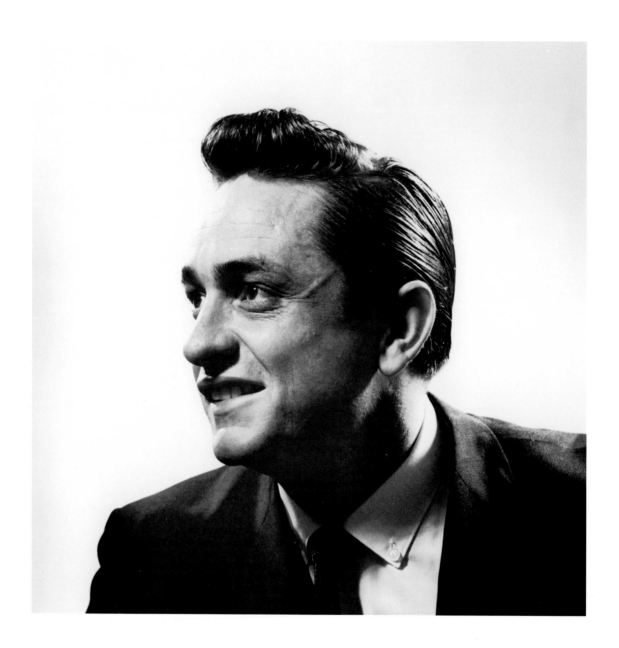

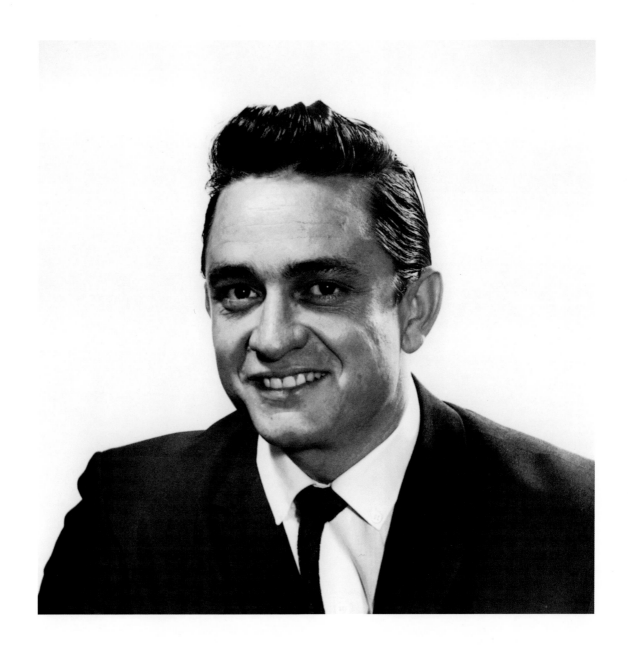

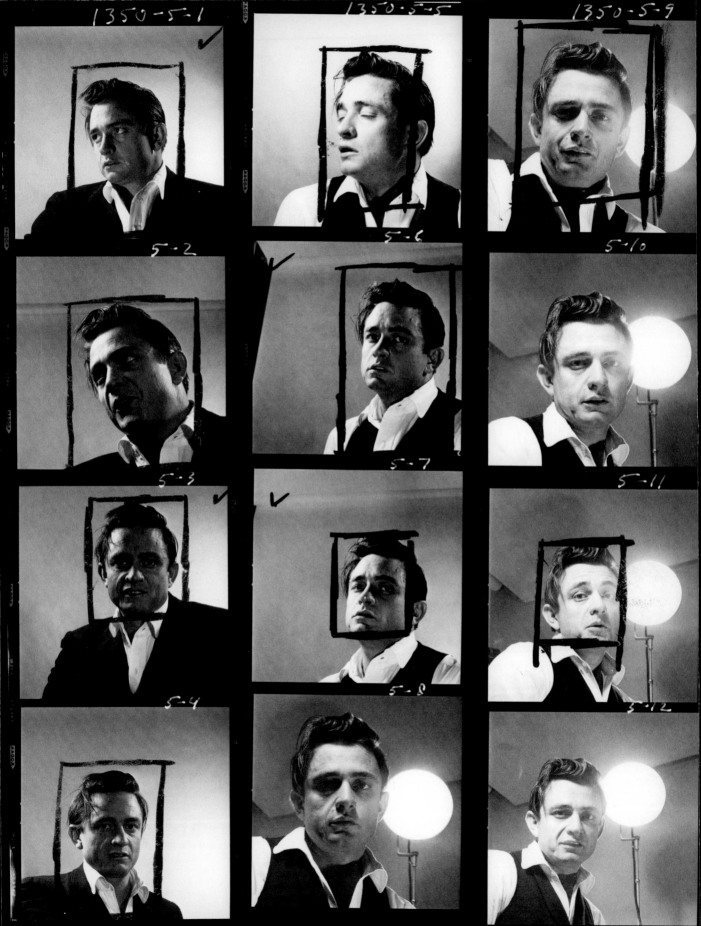

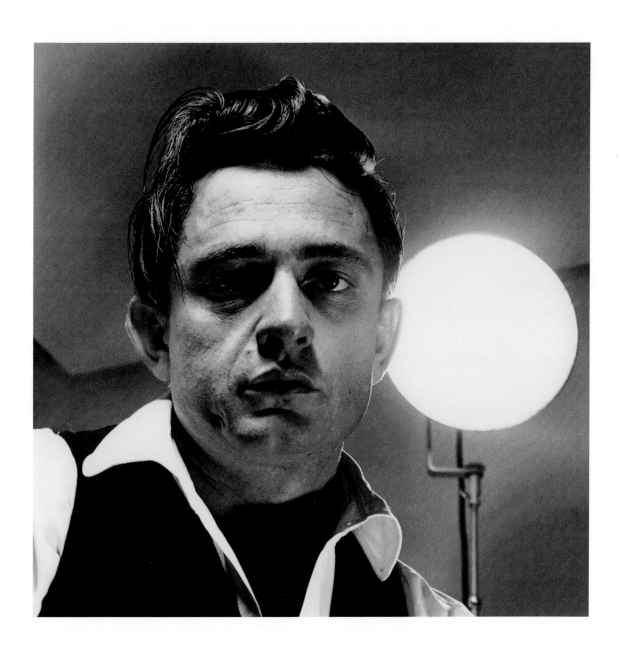

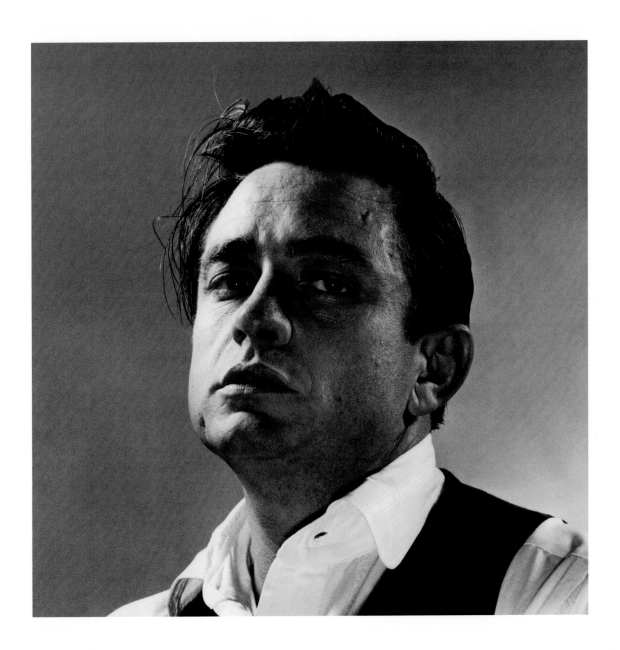

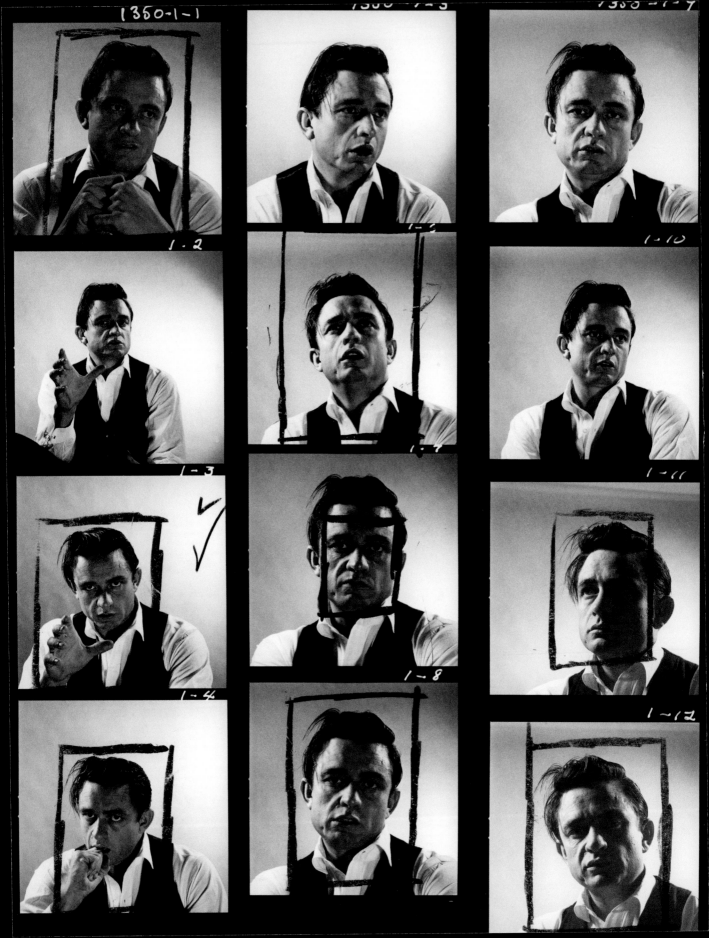

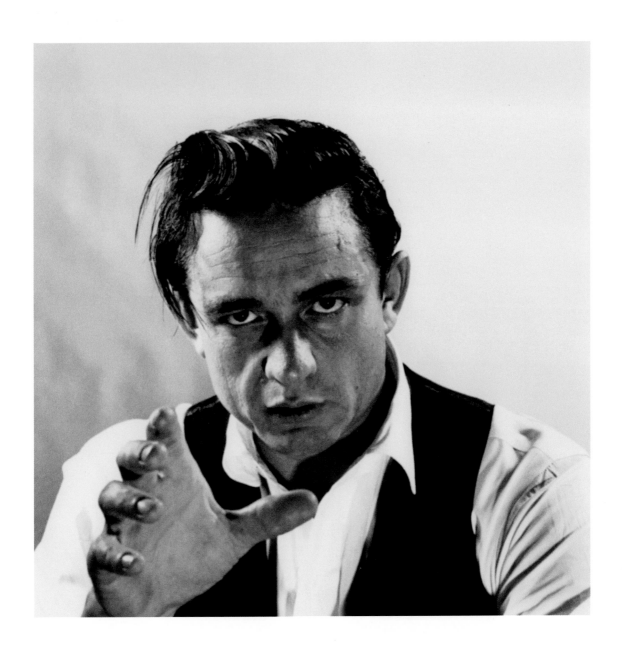

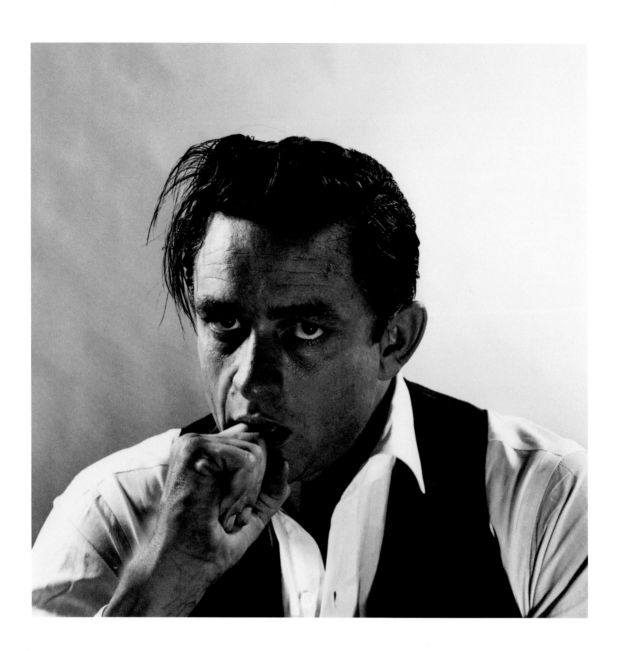

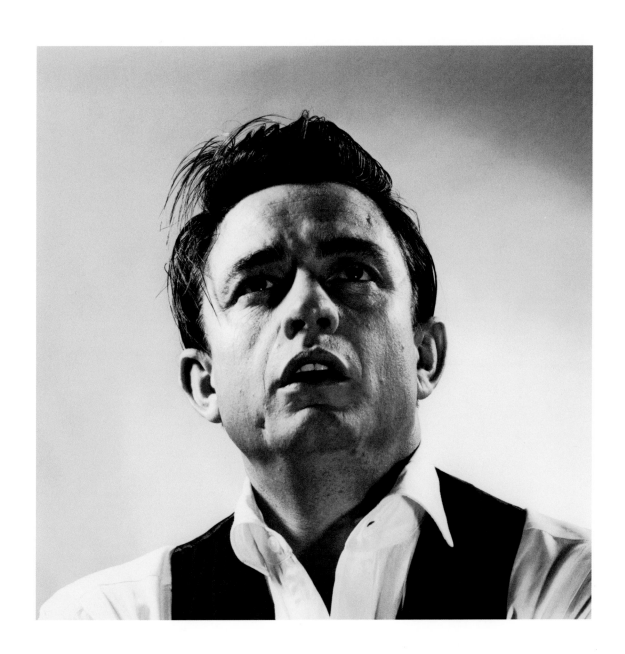

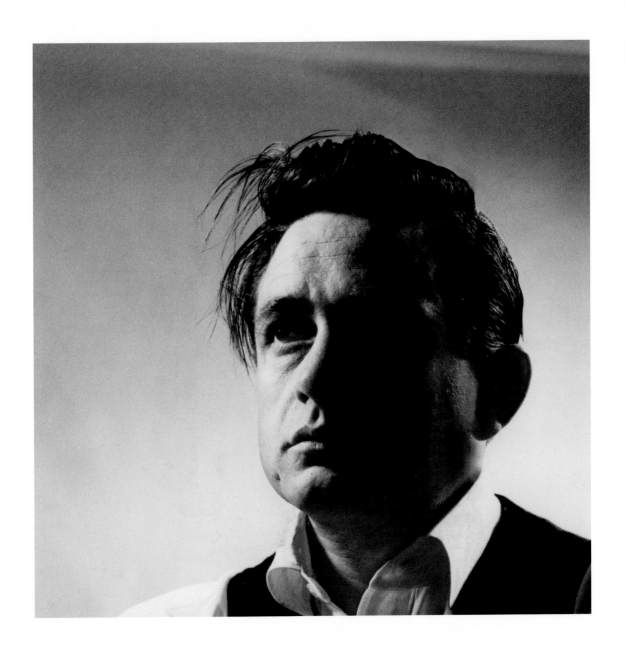

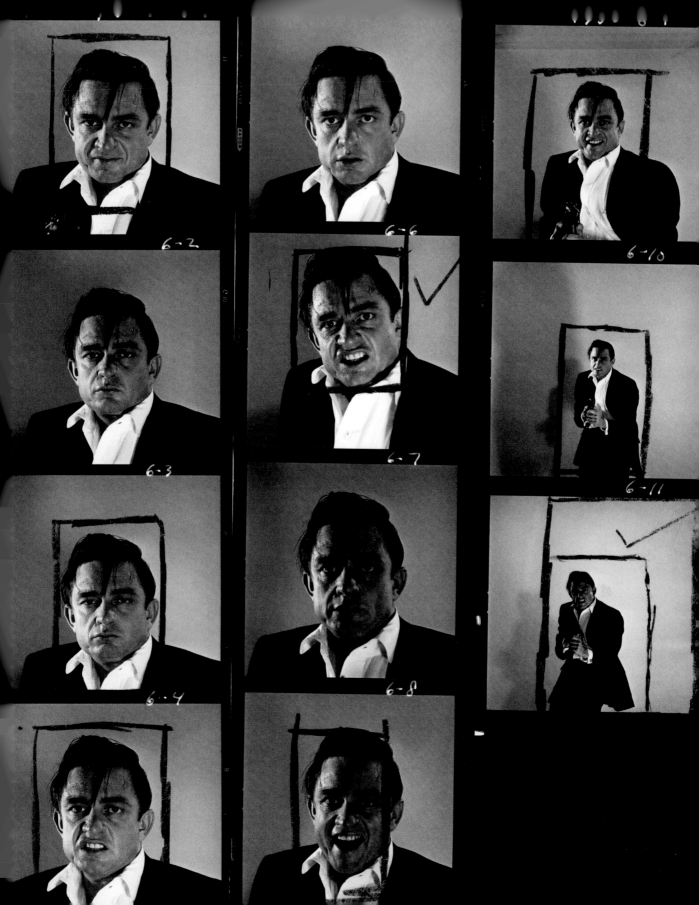

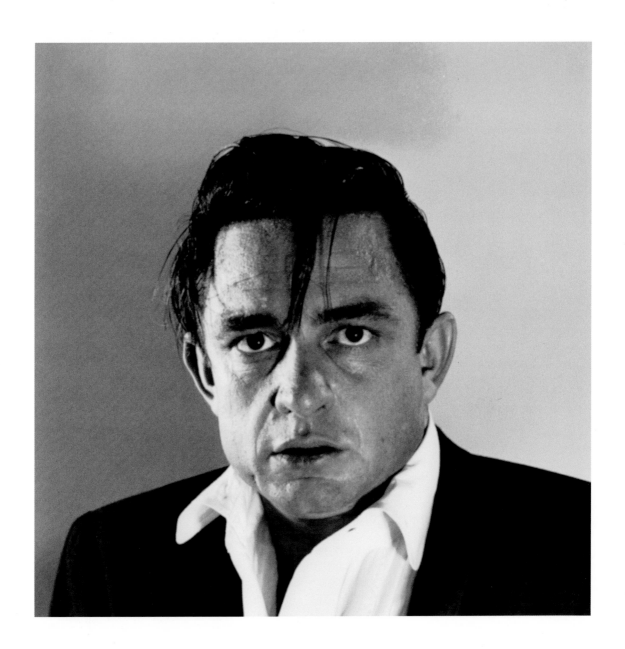

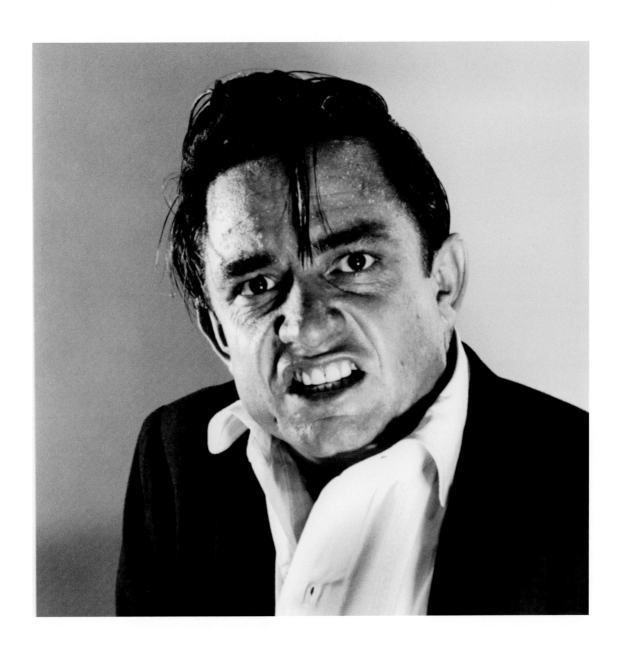

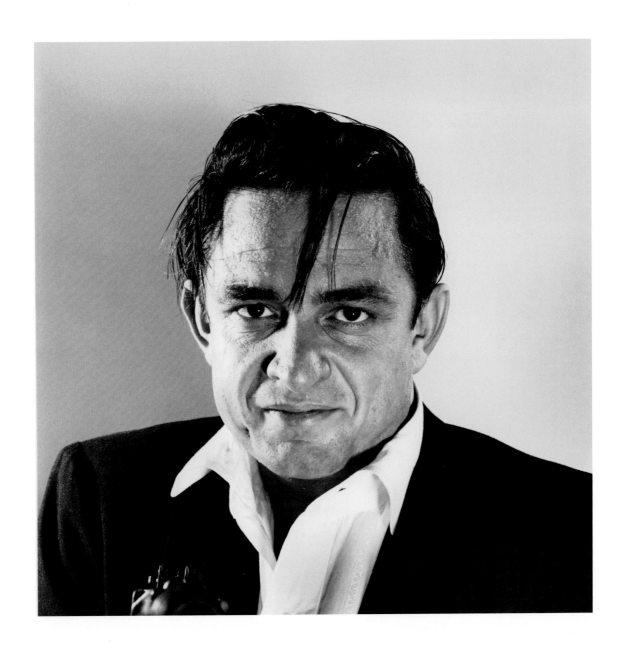

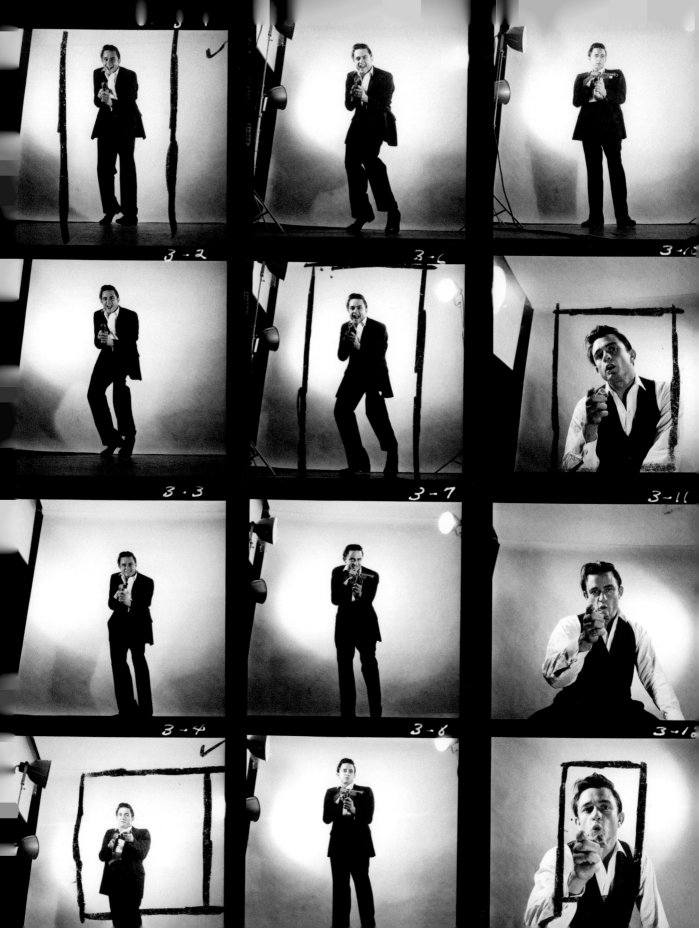

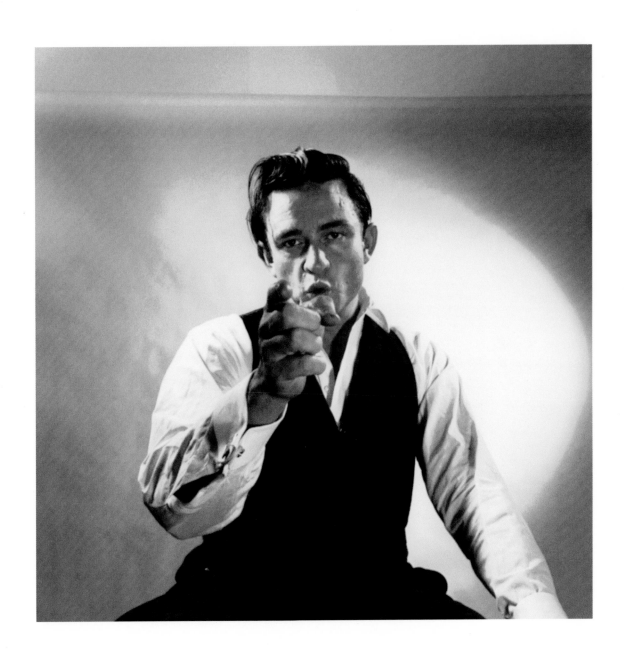

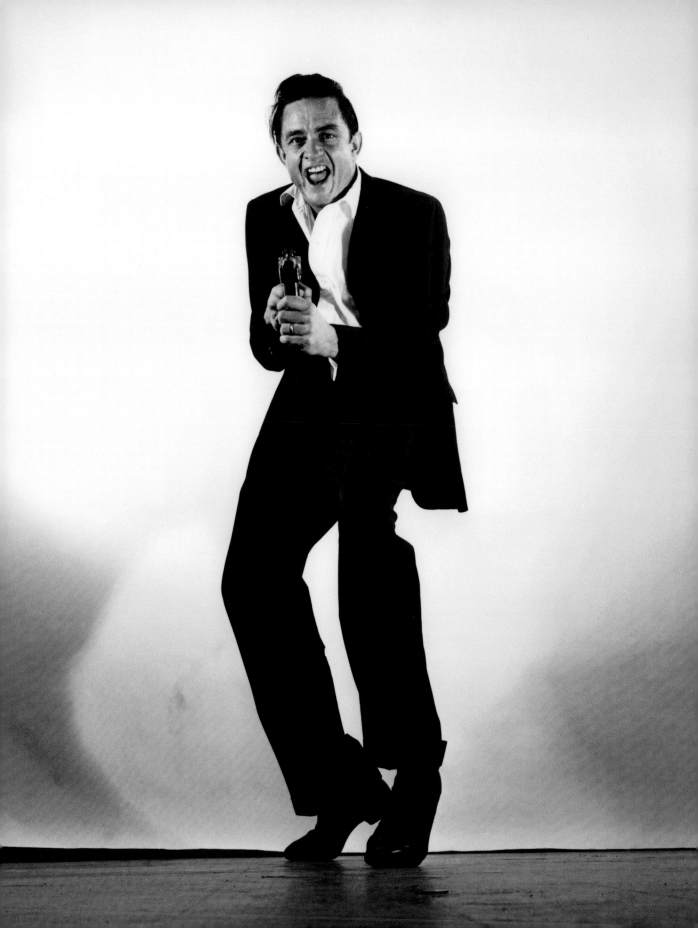

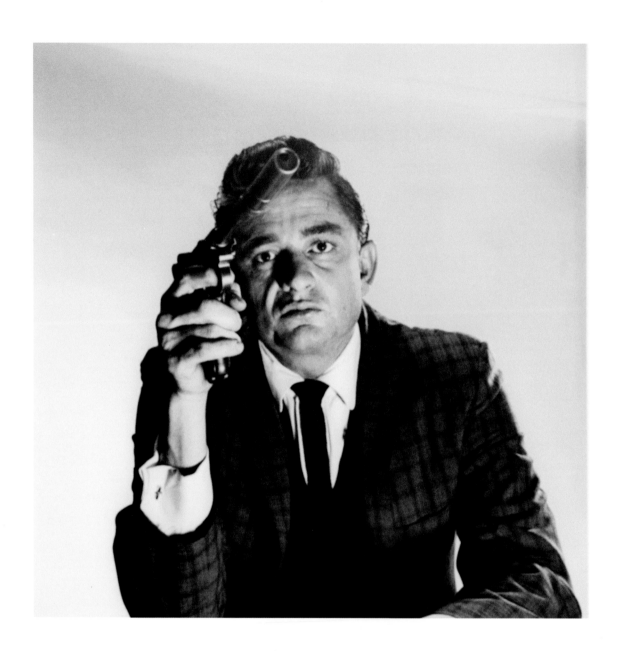

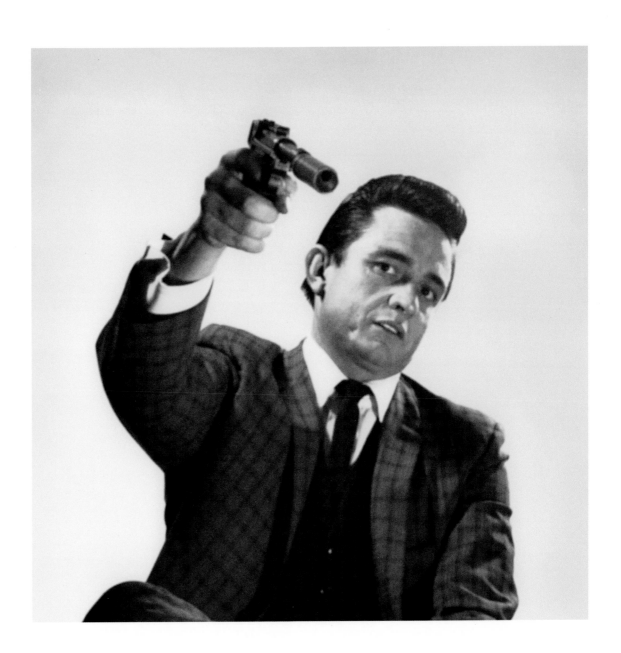

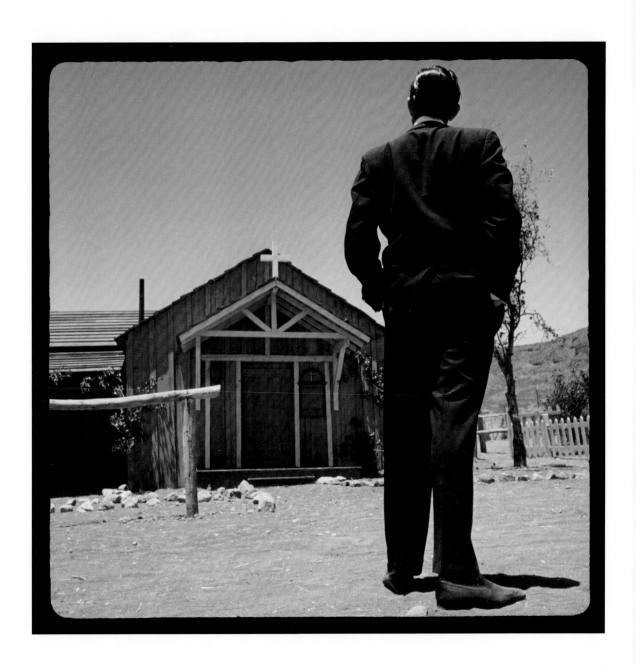

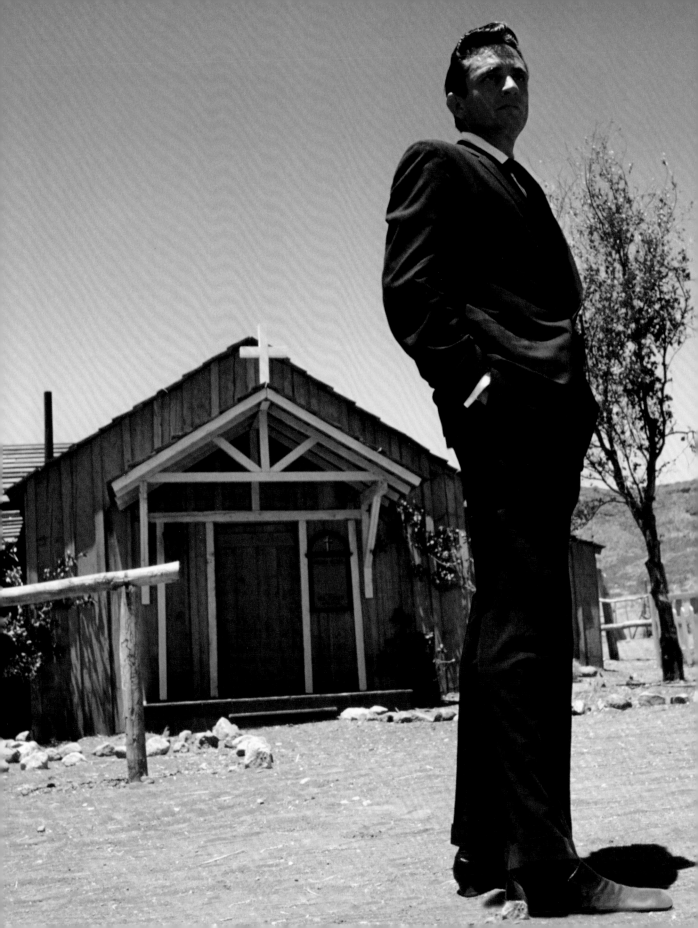

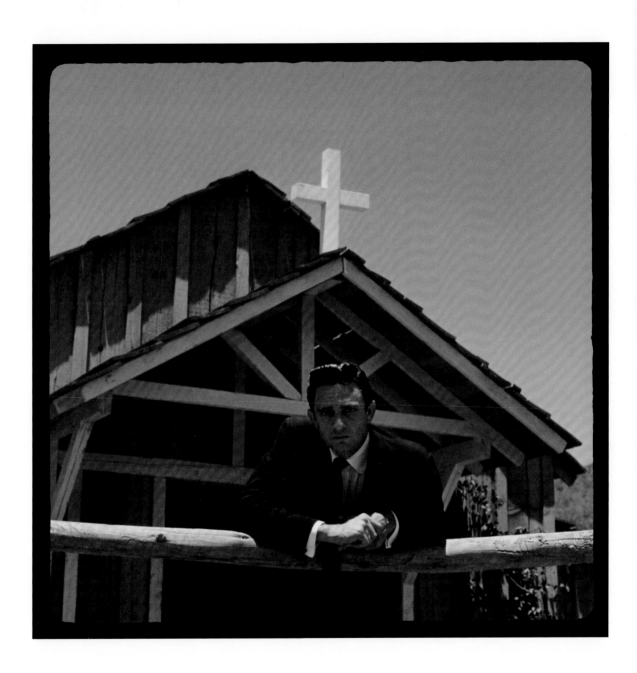

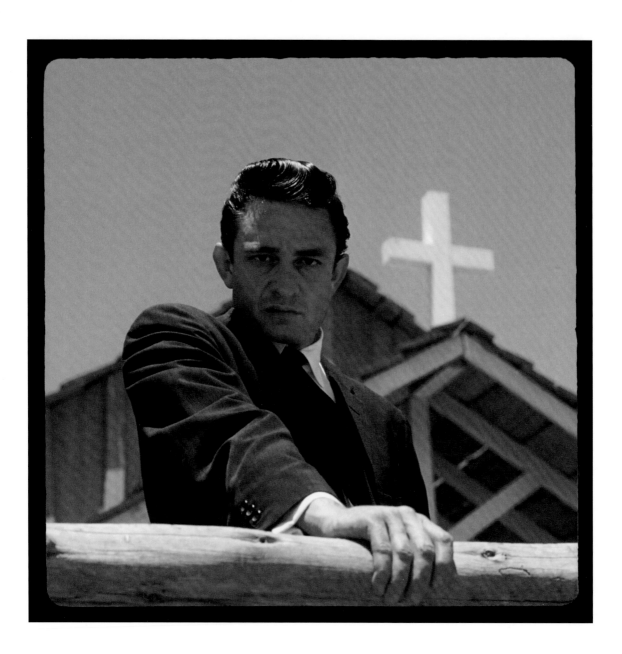

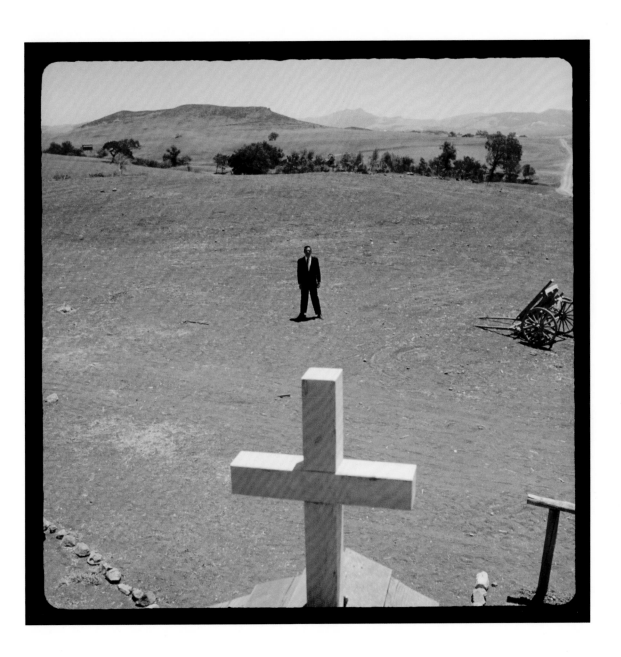

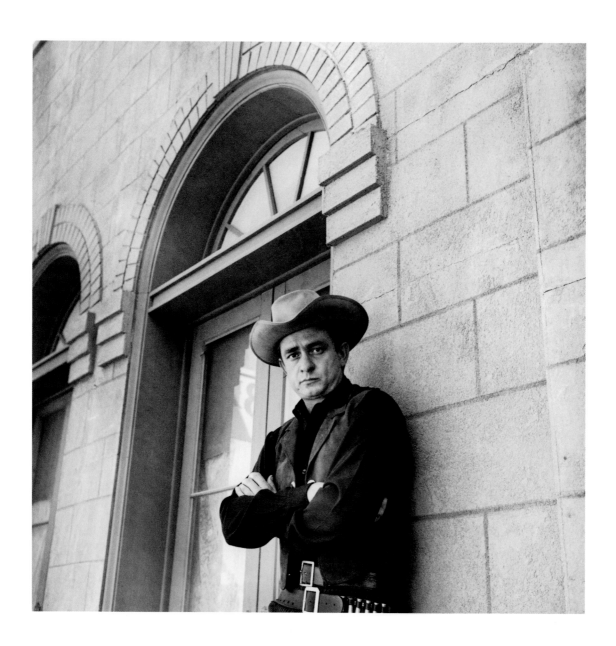

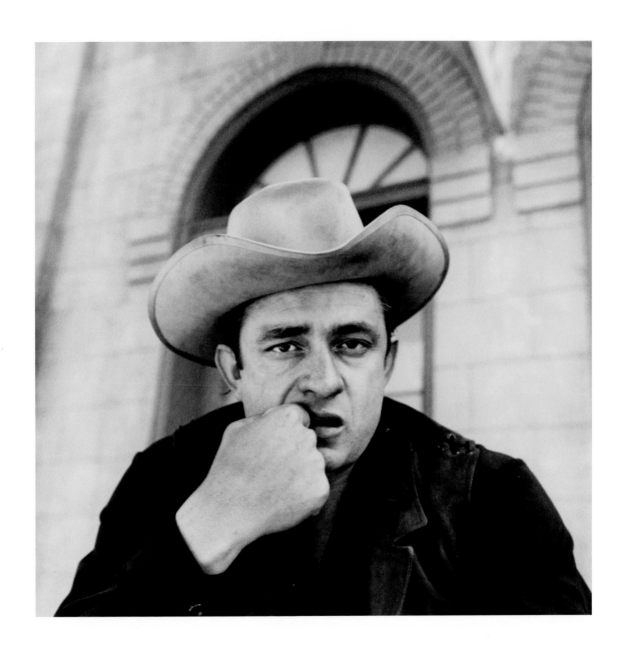

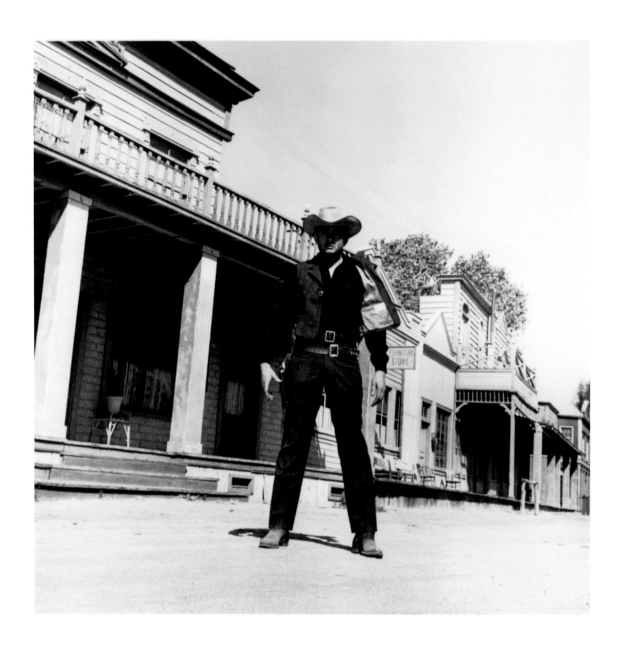

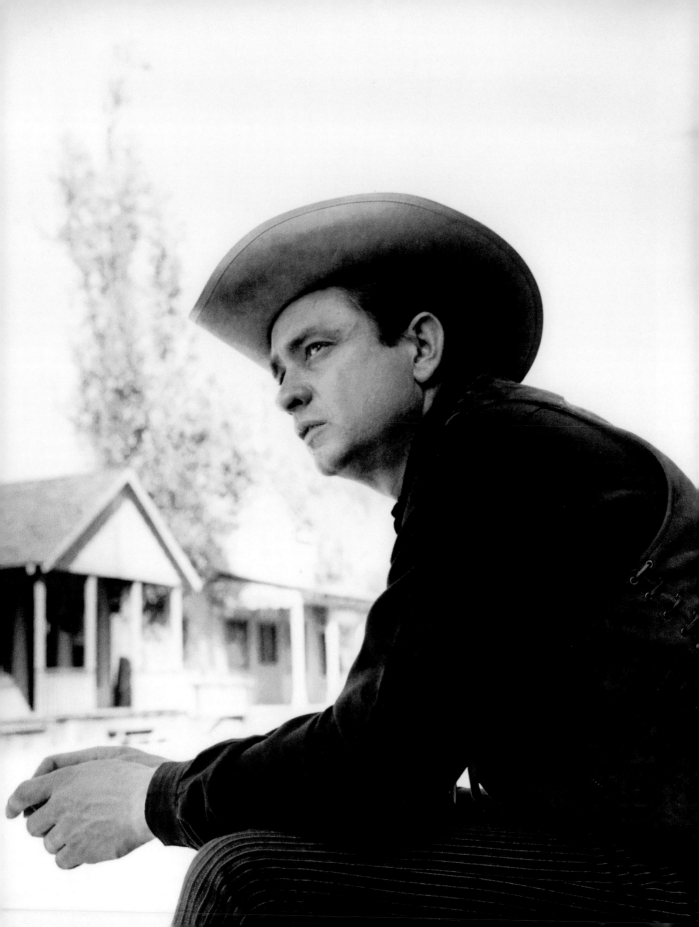

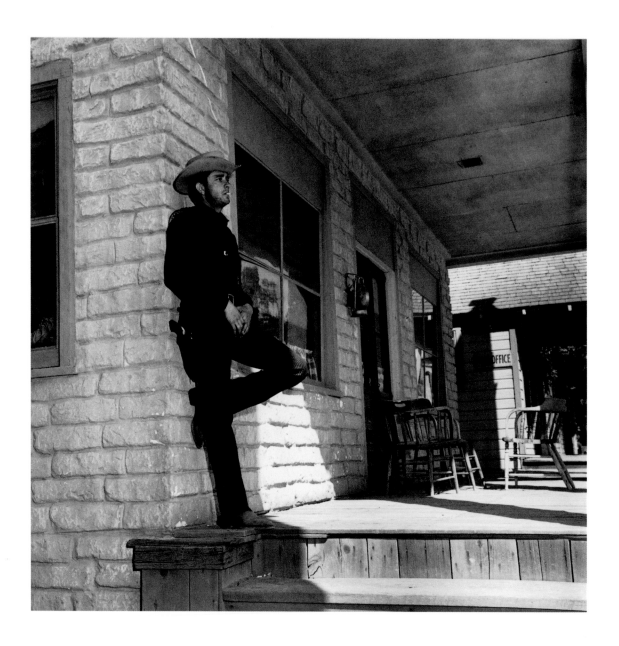

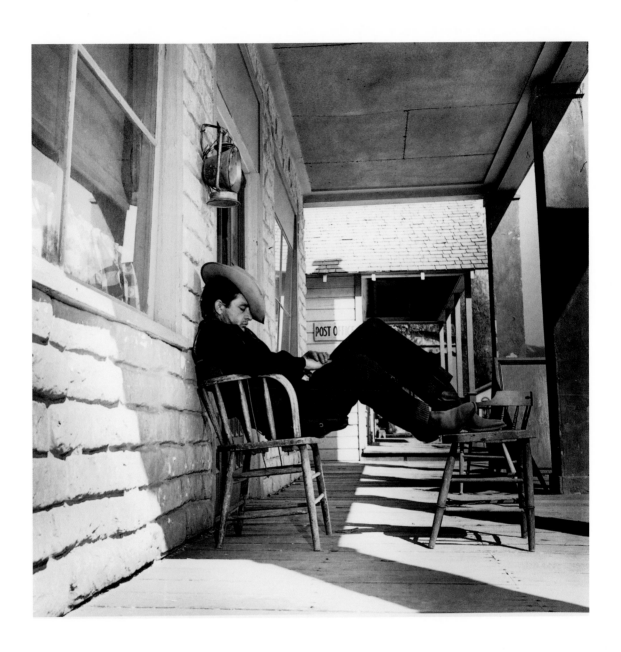

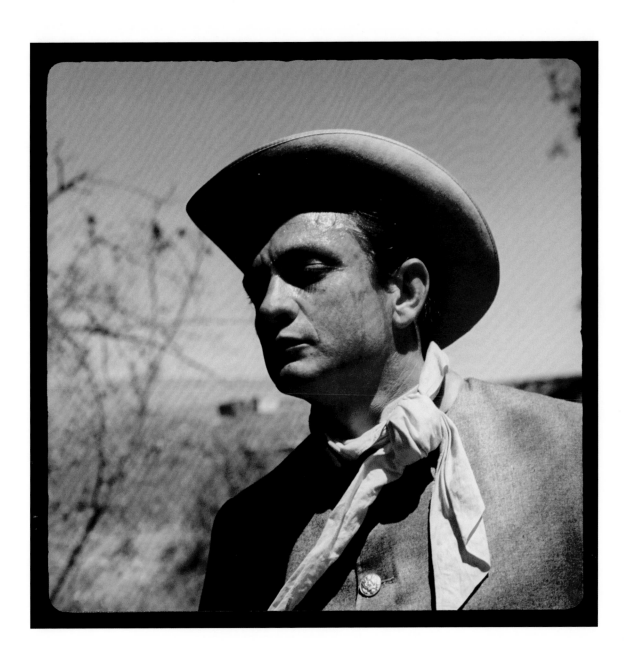

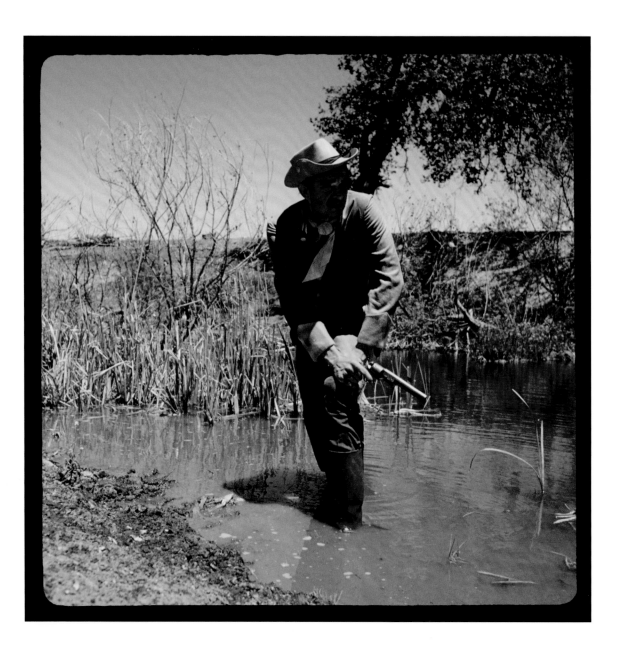

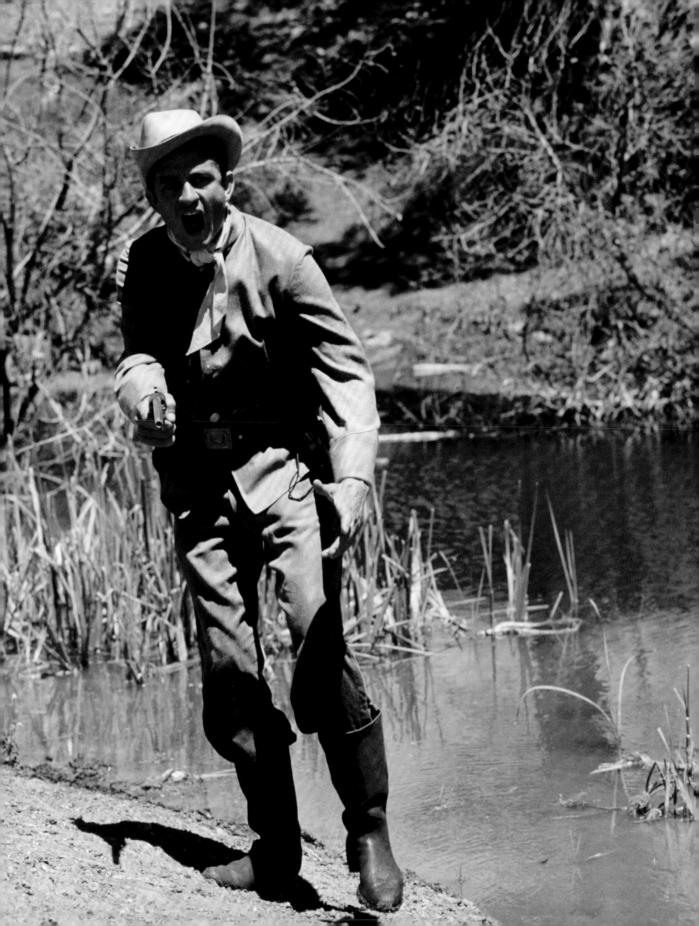

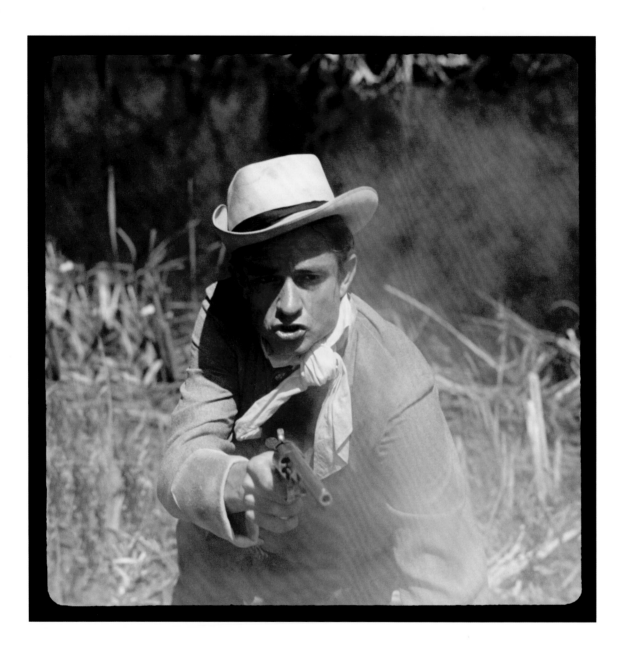

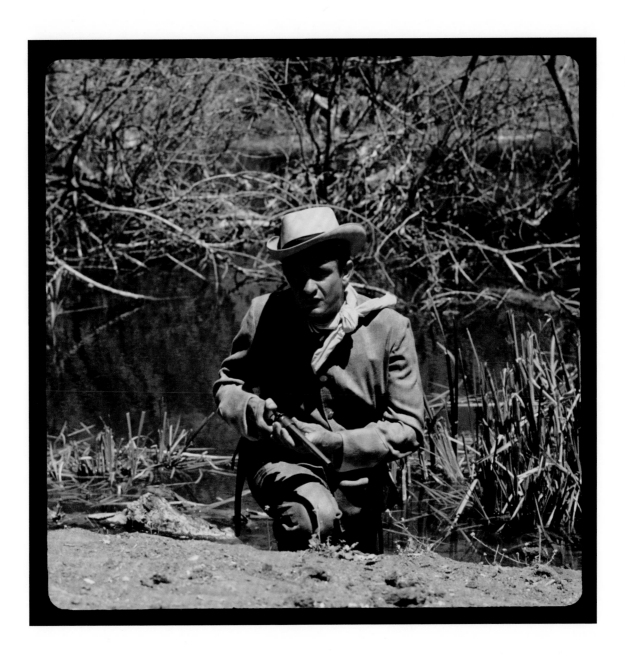

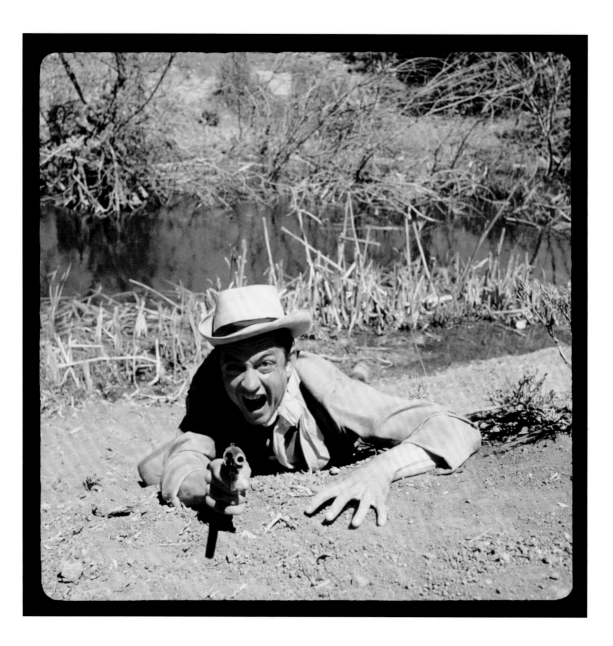

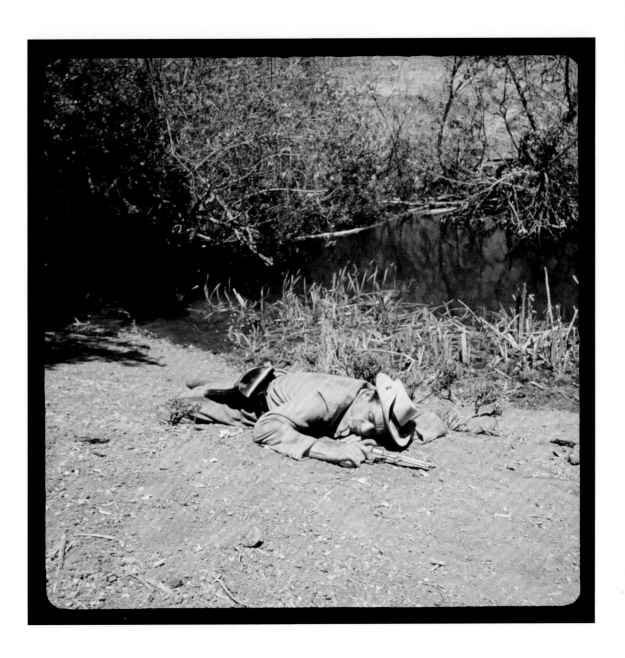

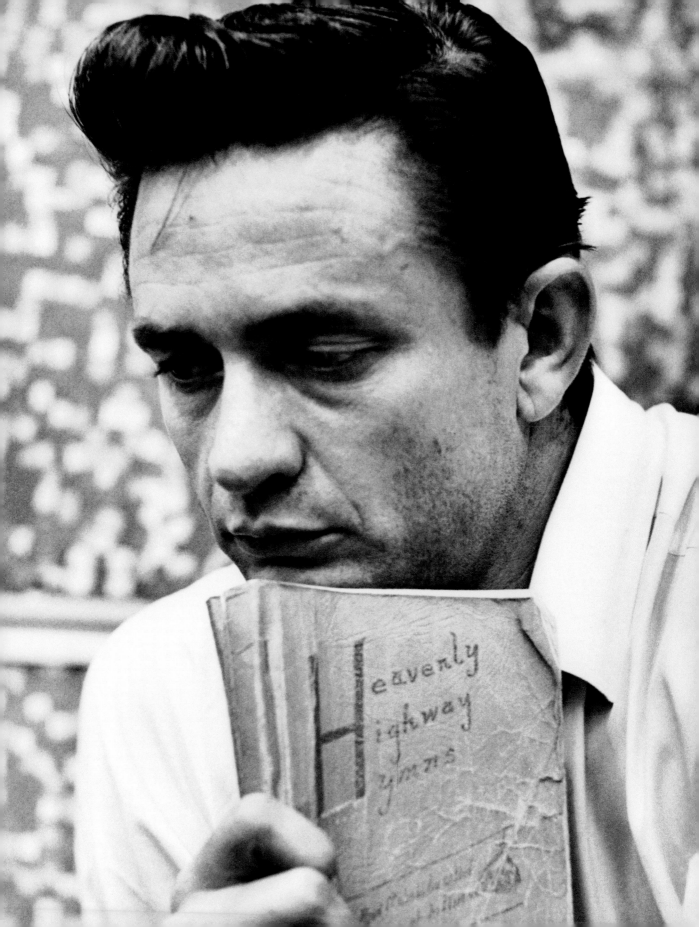

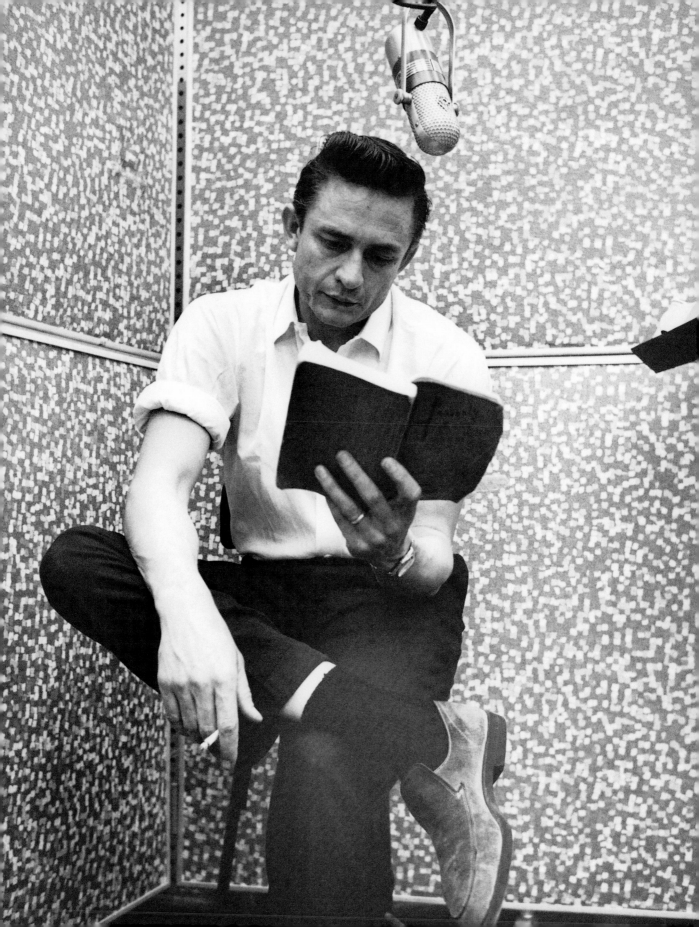

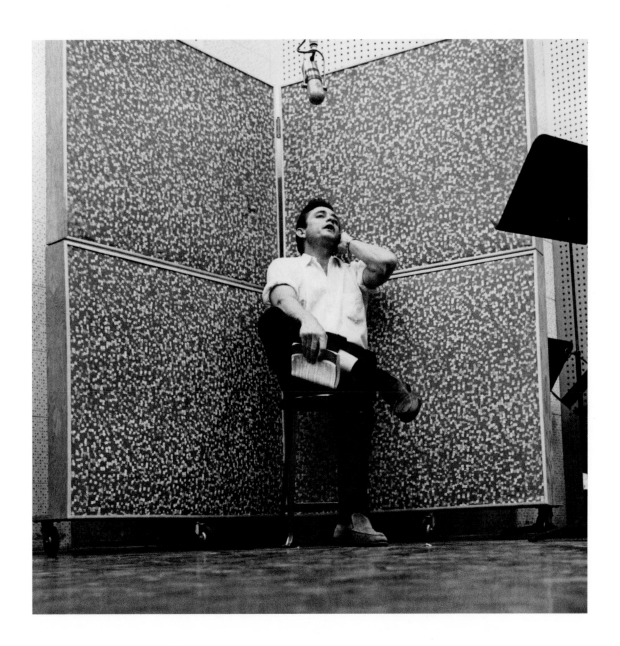

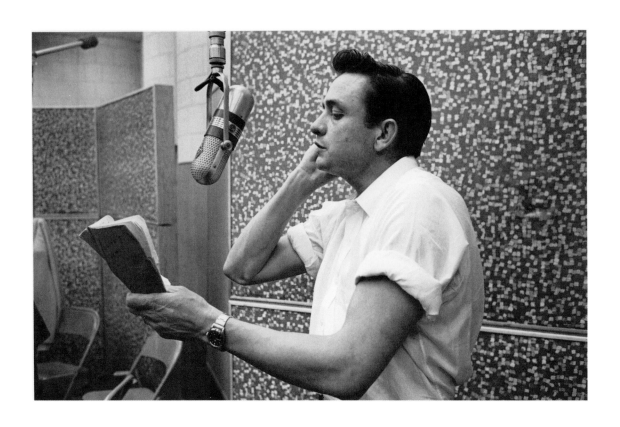

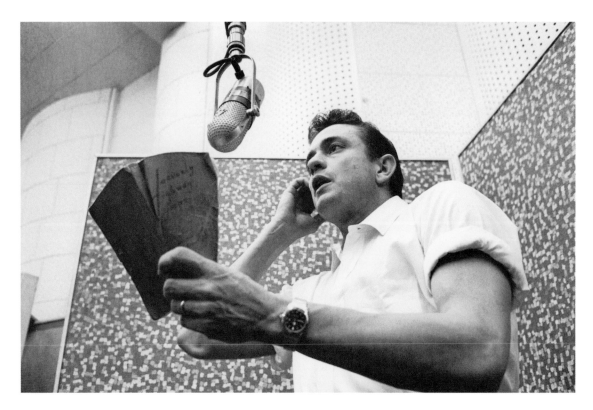

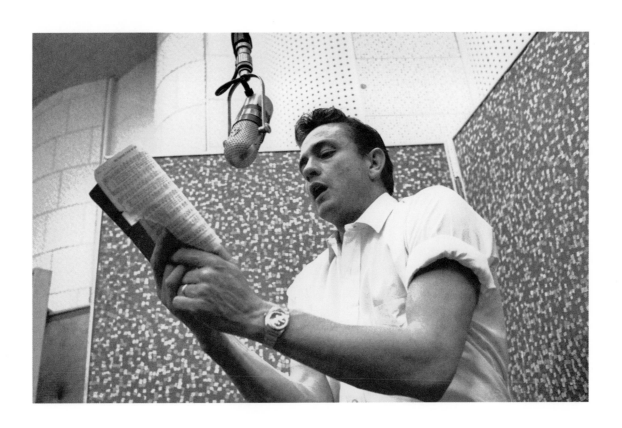

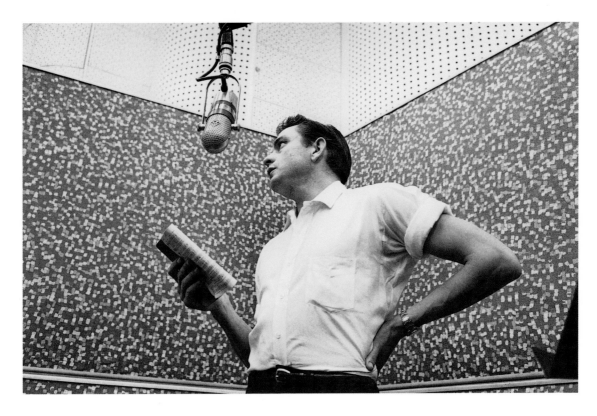

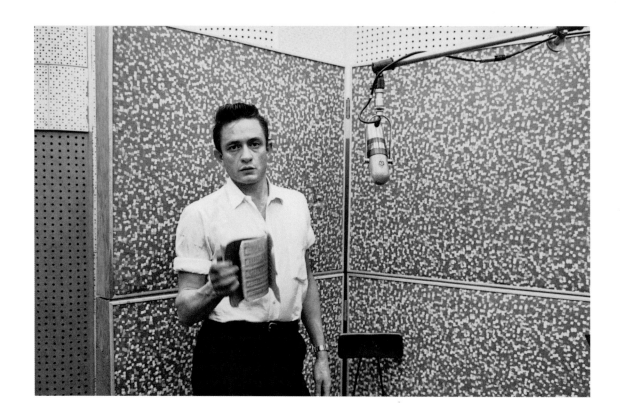

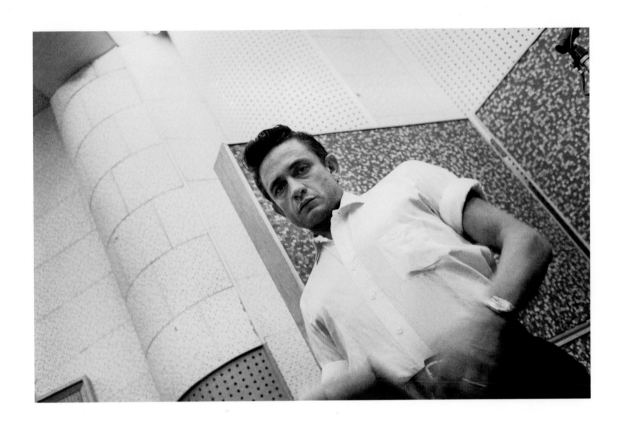

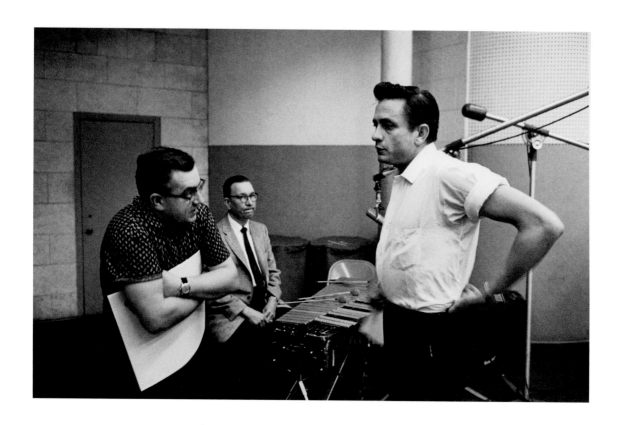

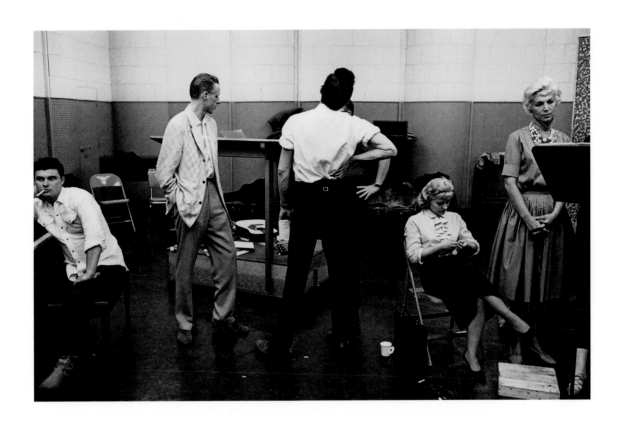

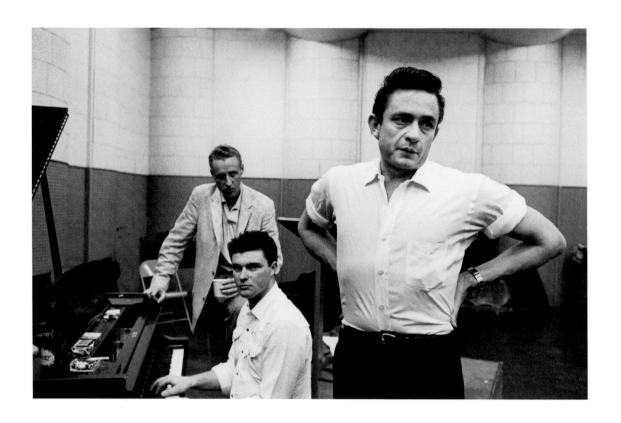

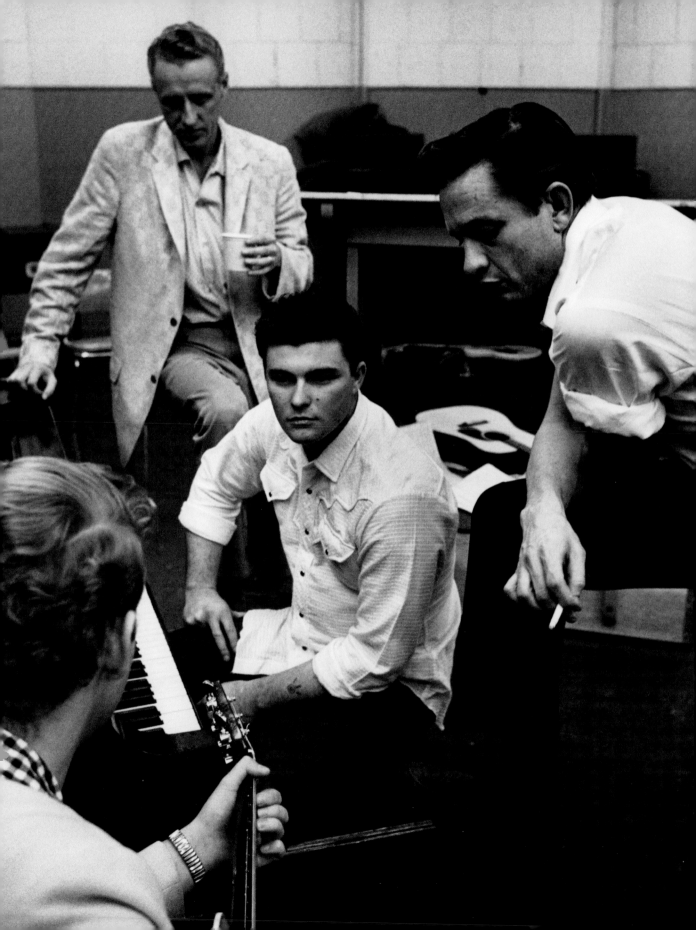

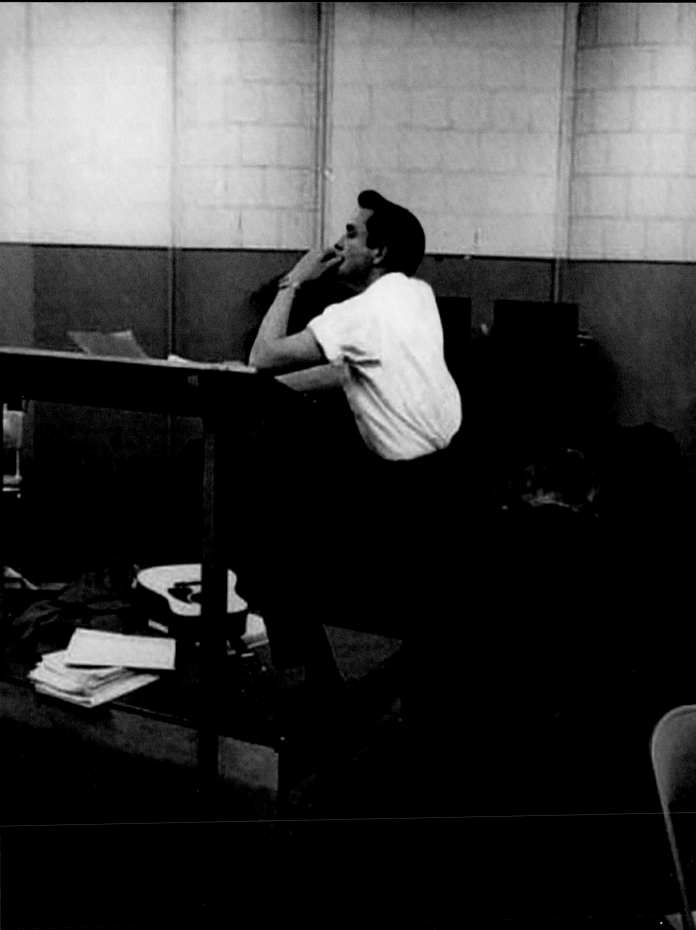

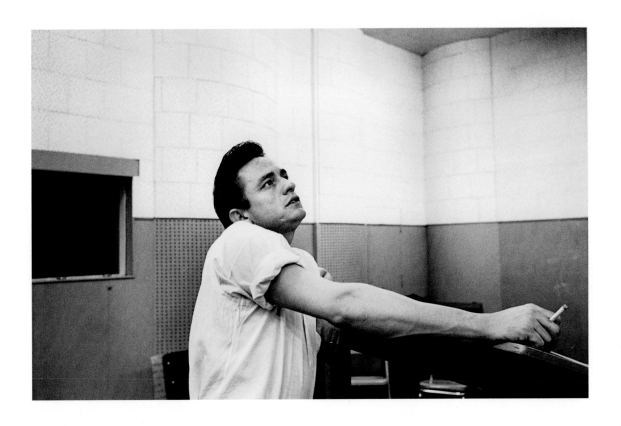

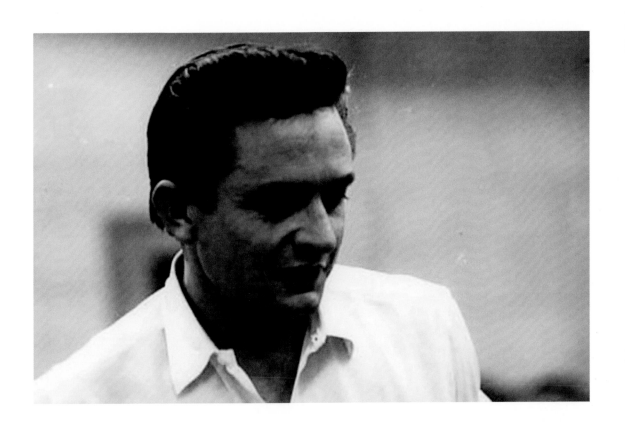
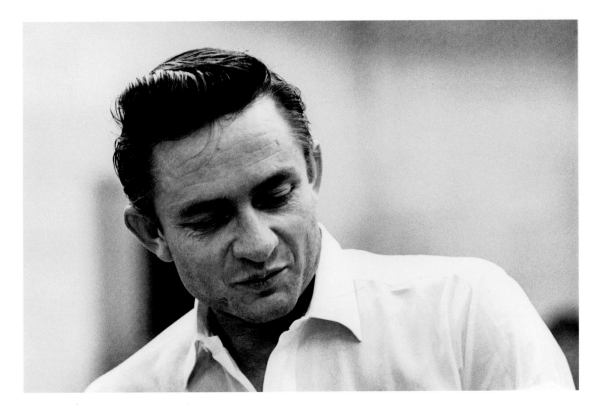

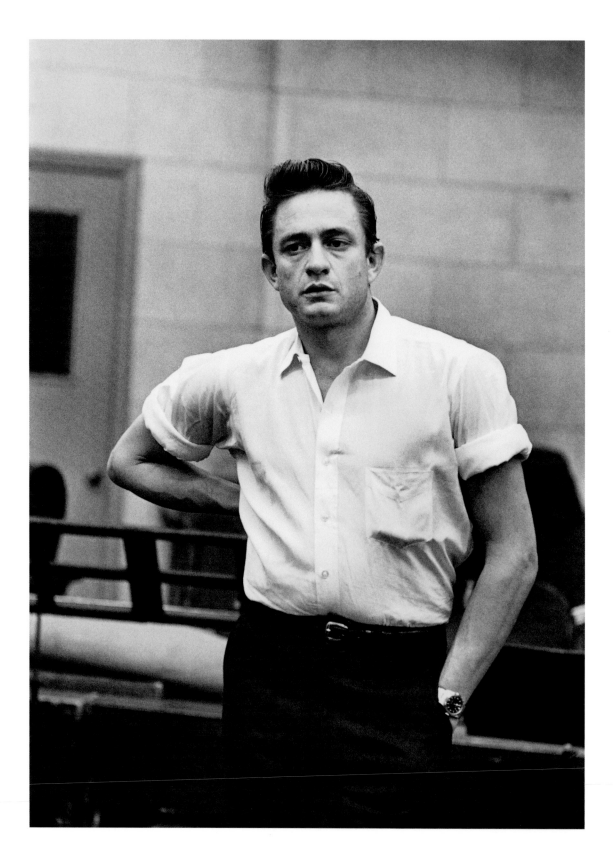

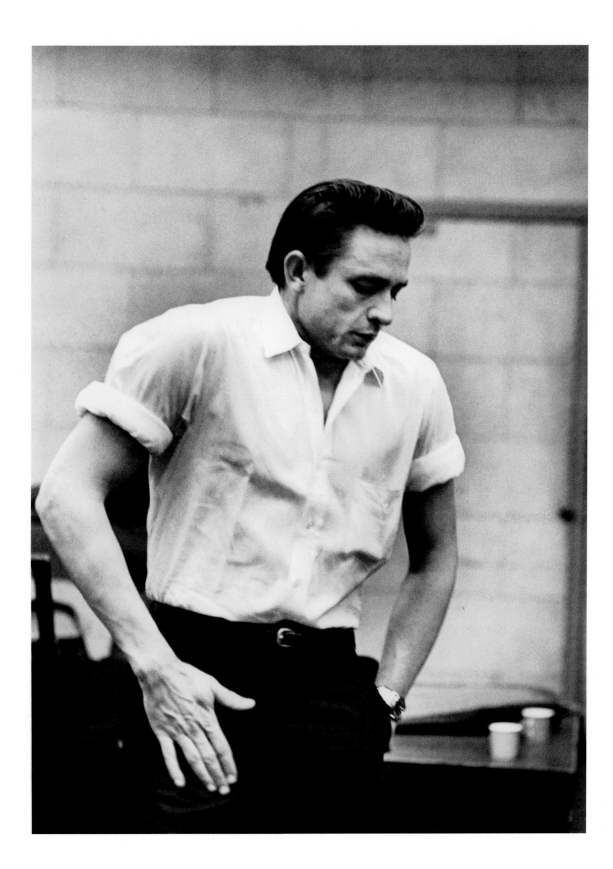

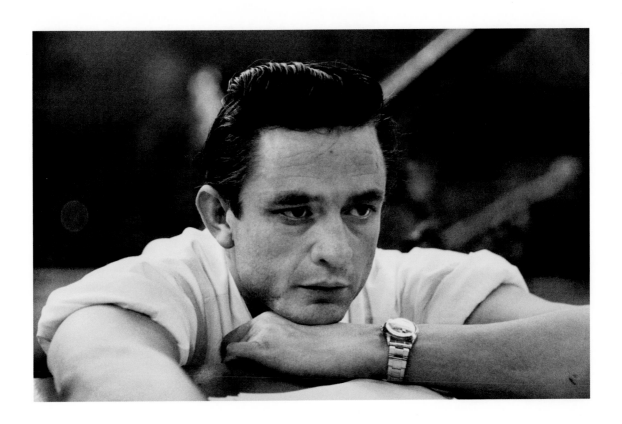

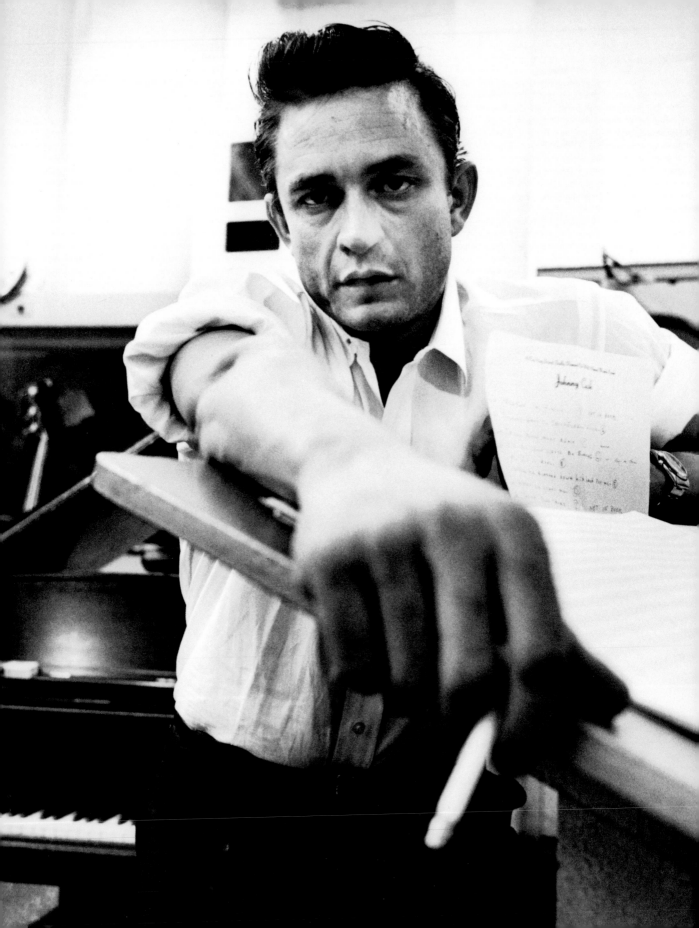

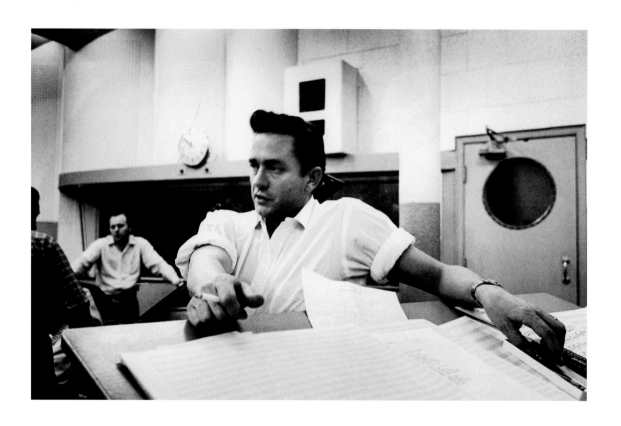

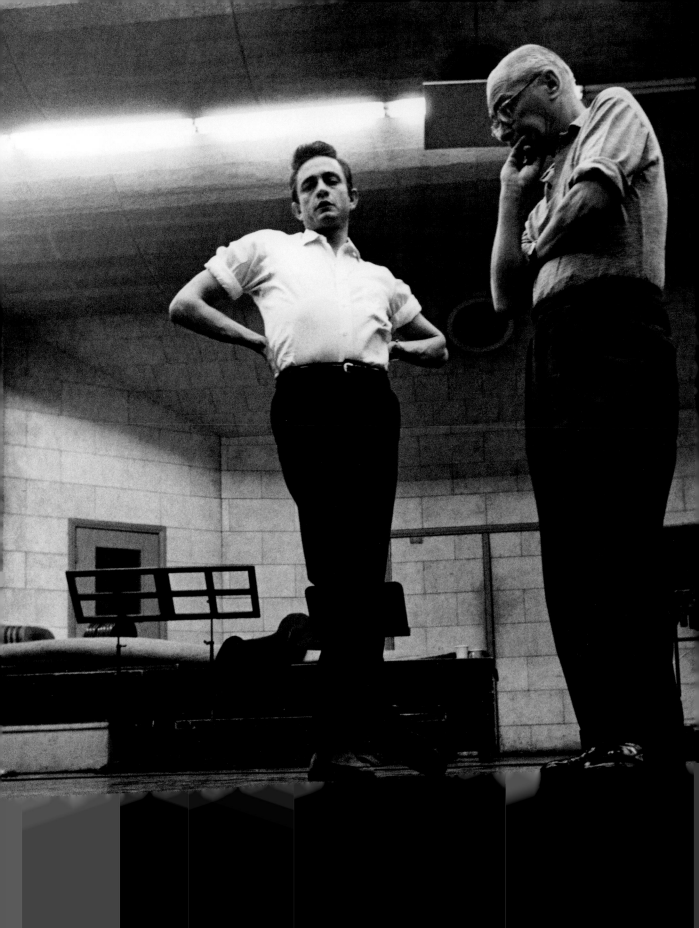

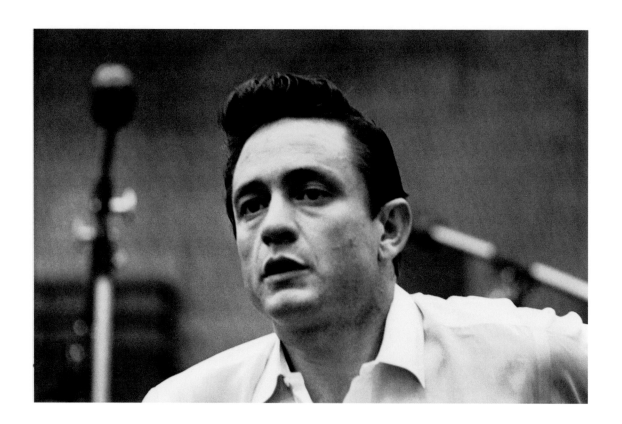

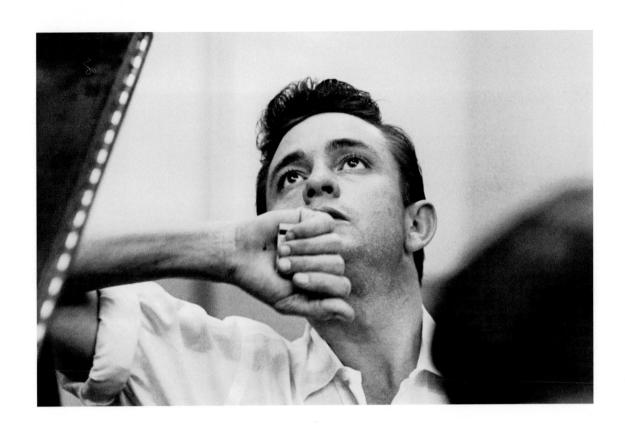

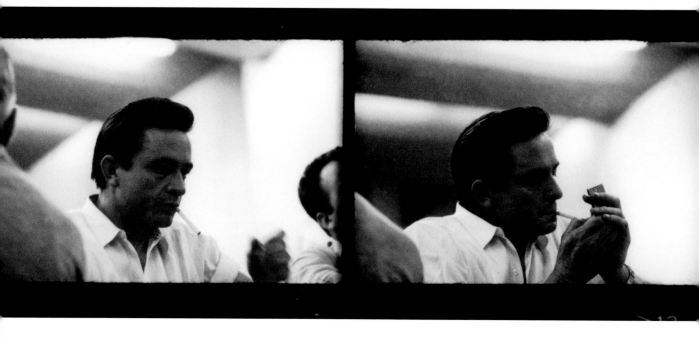

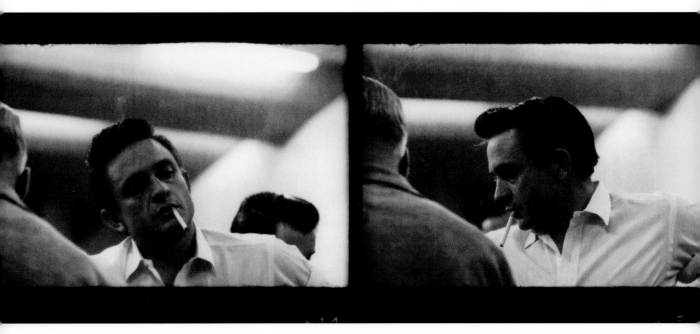

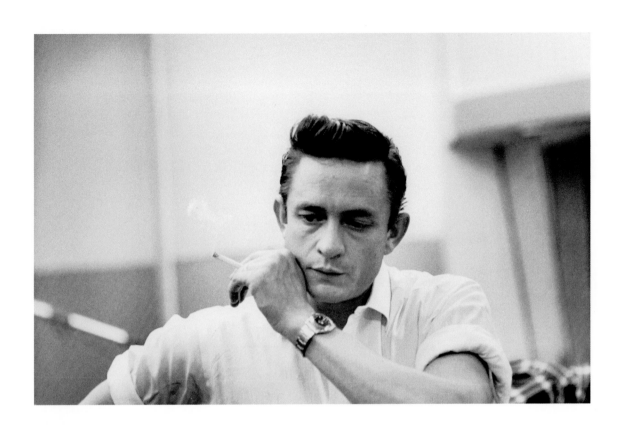
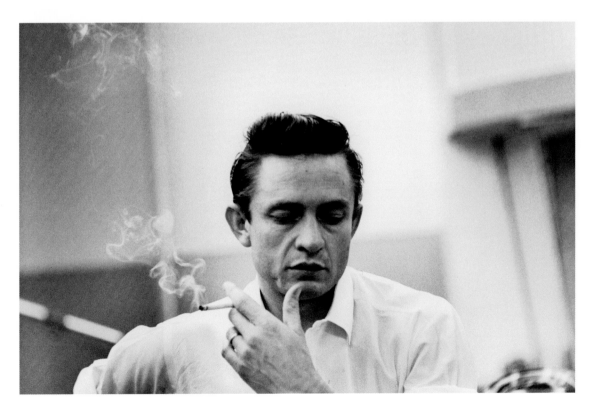

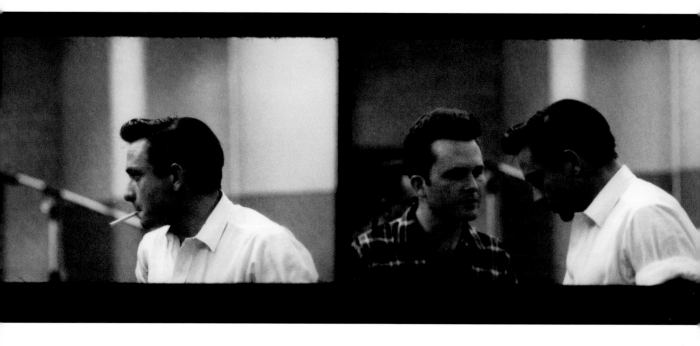

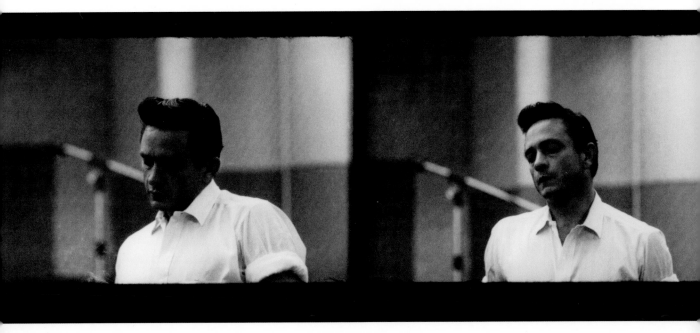

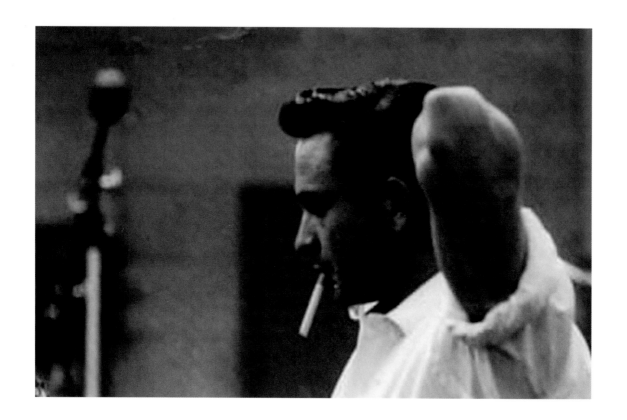

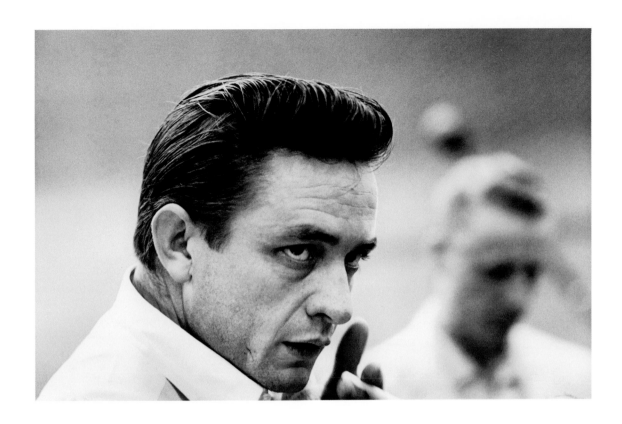

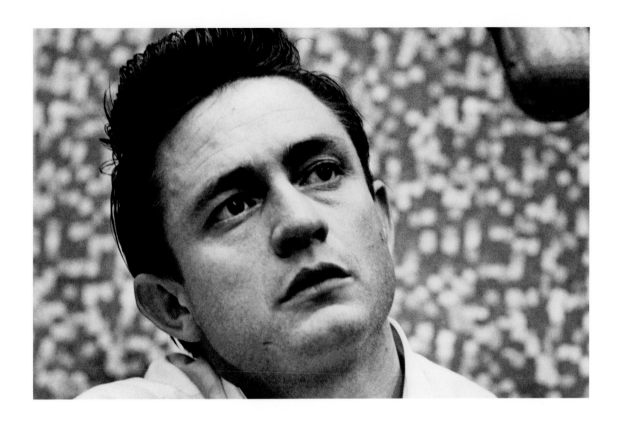

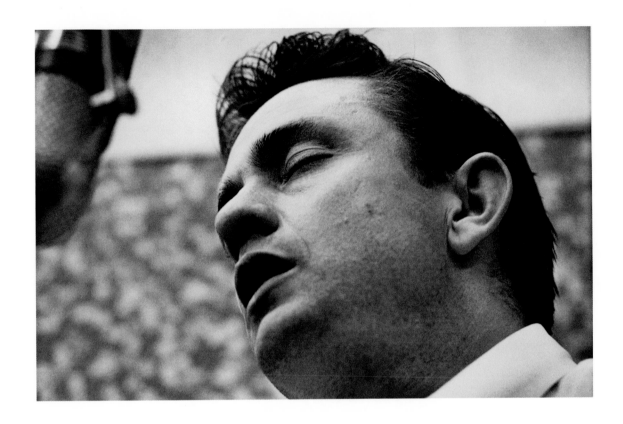

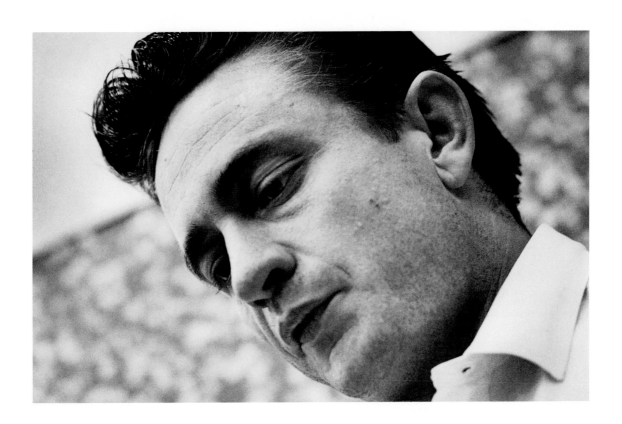

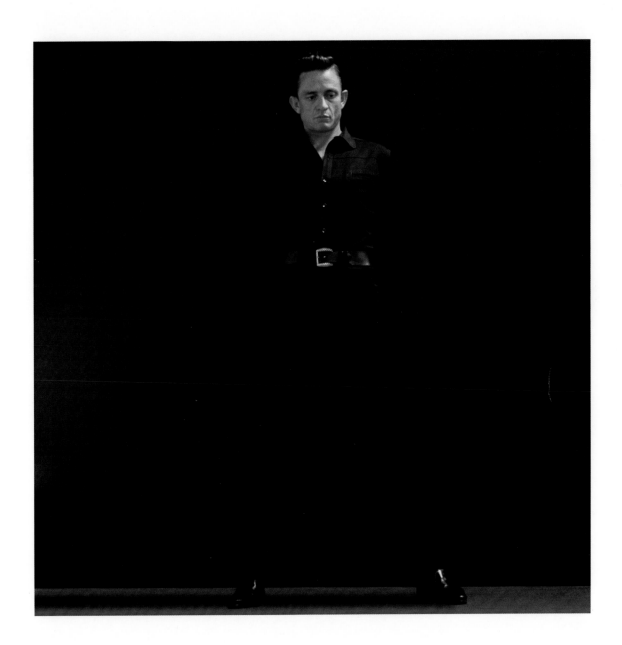

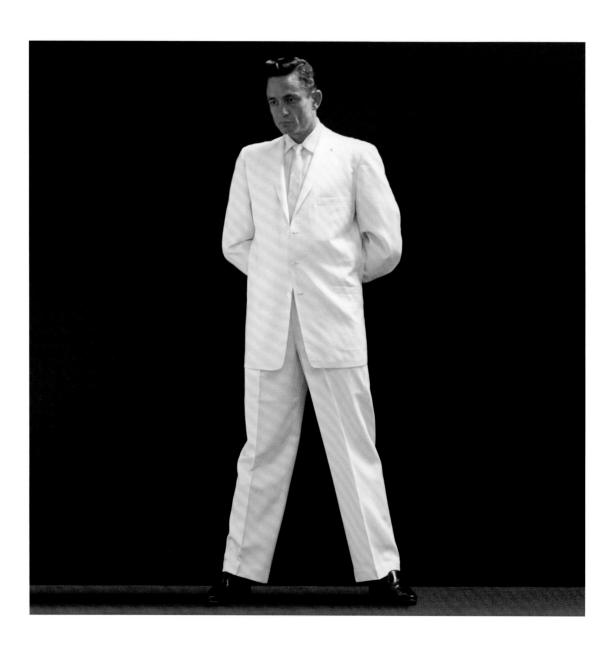

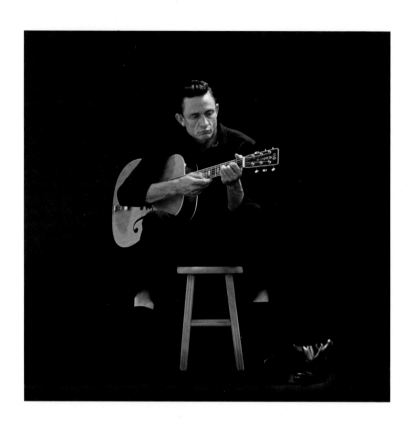

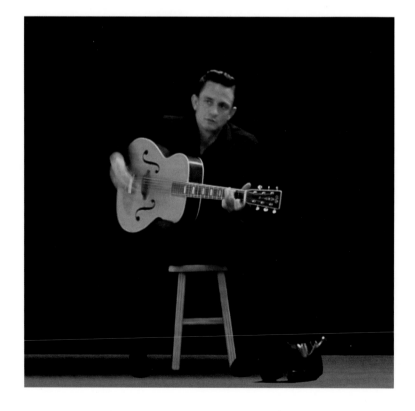

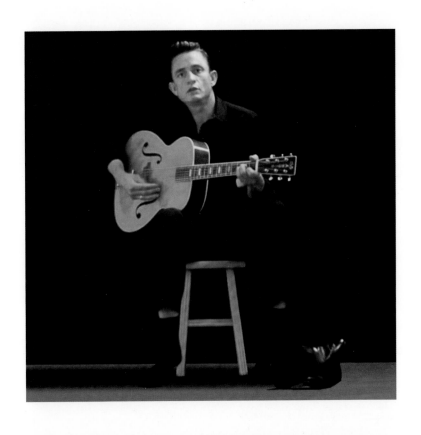

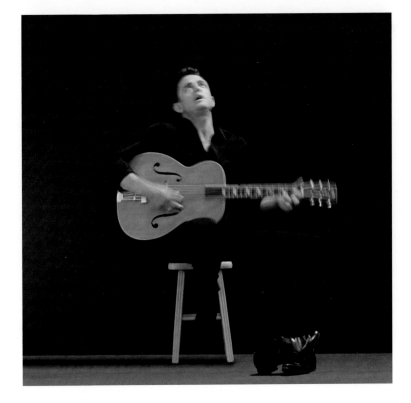

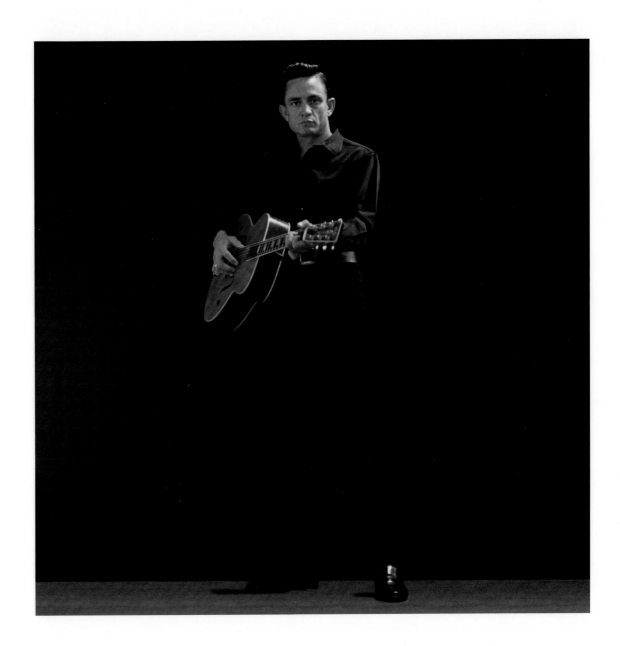

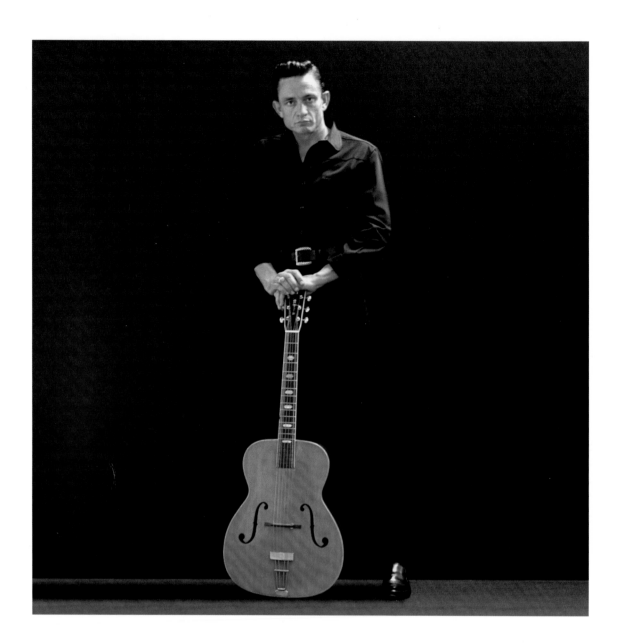

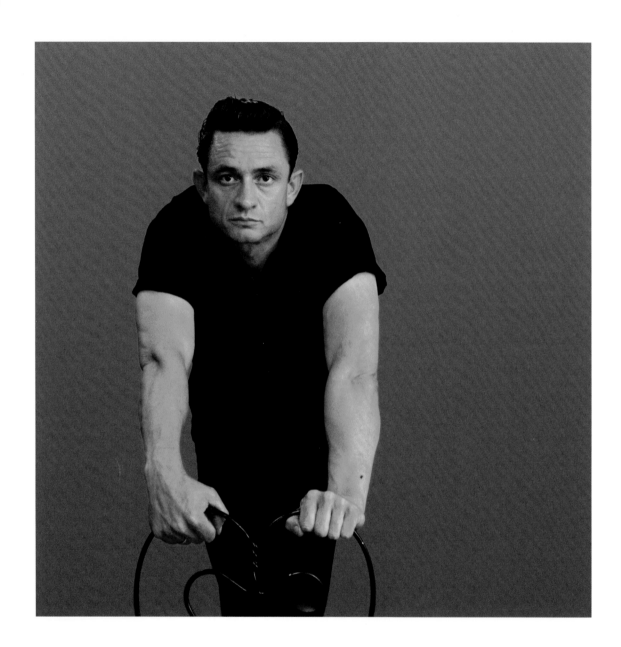

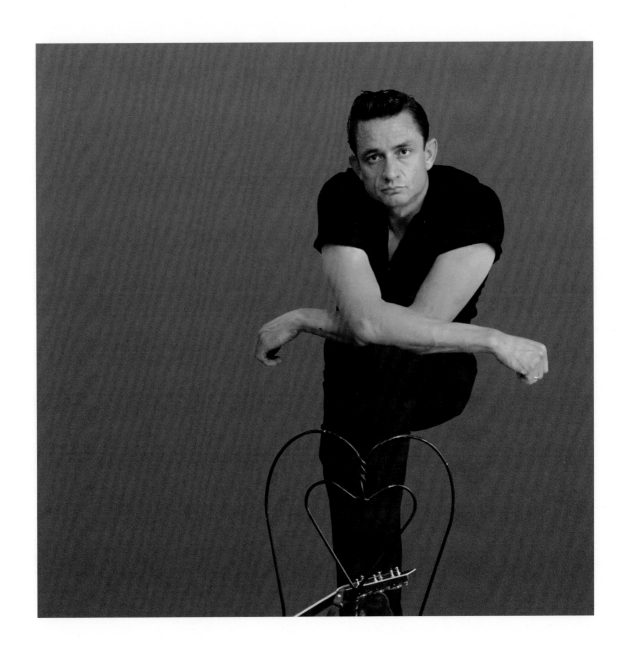

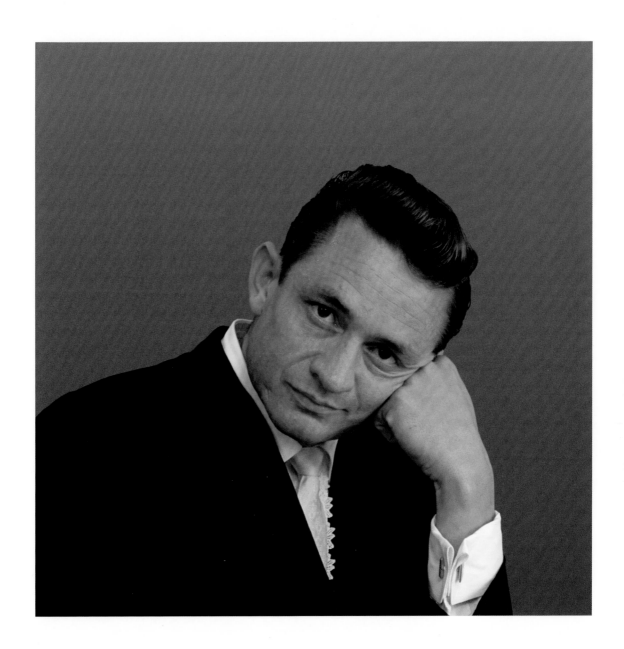

ACKNOWLEDGMENTS

The photographs of Johnny Cash reproduced in this book were taken by Leigh Wiener in five sessions, from April 1960 to April 1962. The exterior photographs in cowboy costume on pages 32–37 were taken at Melody Ranch, Newhall, CA, on April 14, 1960. The photograph on page 35 was featured on the cover of the Sun Records collection *Now Here's Johnny Cash*, released in 1961. The black-and-white portraits on pages 1–25 were taken at the Leigh Wiener Studio in Los Angeles in August 1960. The photographs on pages 46–87 were taken during the recording of *Hymns from the Heart* in June 1961. The color photographs on pages 27–31 and 39–45 were taken on location near Los Angeles on June 29, 1961. *Hymns from the Heart* was released by Columbia Records in 1962, and featured a cover photo by Leigh Wiener from the "church" series reproduced here on pages 27–31. The color portraits on pages 89–101 were taken at the Leigh Wiener Studio in Los Angeles in April 1962. A photograph from the latter session, not reproduced here, was featured on the cover of the 1962 Columbia Records LP *The Sound of Johnny Cash*.

For their invaluable assistance in the production of *Johnny Cash: Photographs by Leigh Wiener* the editors would like to thank AC Berkheiser, Kim Blanchette, Graham Nash, and Devik Wiener. A special note of appreciation goes to Wing Shun at Nardulli Inc. in Los Angeles, who made the black-and-white prints reproduced in this volume. Thanks also to Cilla Bachop and the staff at Blanchette Press.

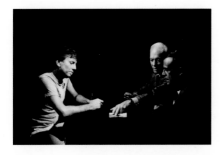

LEFT TO RIGHT: Guest Graham Nash, host Leigh Wiener, and co-host George Fenneman on Leigh Wiener's "Talk About Pictures" television show, KNBC, Los Angeles, August 6, 1981. PHOTO: Jeff Sedlik.

Five Ties Publishing, New York
www.fiveties.com

Produced by Garrett White
Photo edit by Garrett White and Amanda Thorpe
Book design by AC Berkheiser

First edition 2006

Photographs ©Devik Wiener/7410, Inc. 2006, www.leighwiener.com
Preface ©Graham Nash 2006

Printed by Blanchette Press, 8000 River Road, Richmond, BC, Canada V6X 1X7
www.blanchettepress.com

Printed in Canada

ISBN: 0-9777193-1-6